PIERRE DUBREUIL

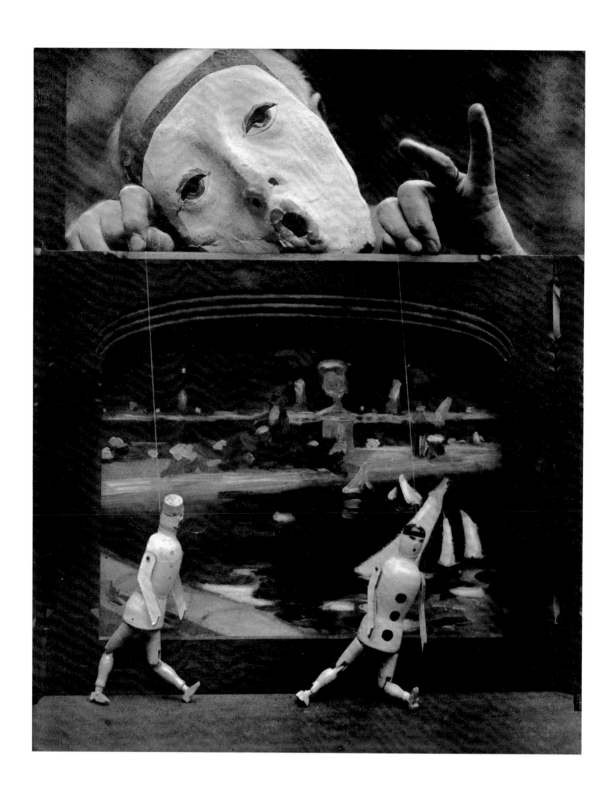

PIERRE DUBREUIL

PHOTOGRAPHS 1896·1935

DUBRONI PRESS, SAN DIEGO

1987

Published on the occasion of the retrospective
exhibition of photographs by Pierre Dubreuil at the
Musée d'Art Moderne, Centre Georges Pompidou,
Paris, October 28, 1987—January 5, 1988

Frontispiece: Pierre Dubreuil, *The Puppets* [self-portrait], c. 1930

 ISBN 0-9619090-0-5
 Published by Dubroni Press
 P.O. Box 7089
 San Diego, California
 92107

Contents

Foreword

"Photography is now within reach of the last imbecile . . . it is the meeting place of all the dry fruit . . . painters who have never painted and tenors without engagements . . . coach drivers and house maids have, within an hour, become 'photographic operators.'"[1]

Thus wrote Nadar in 1857 at a time when photography was still in its infancy, relatively difficult to master, and costly. In 1888, the situation was exacerbated when Kodak marketed a simple, lightweight camera, placing photography within the reach of the masses and paving the way for a popular photography that was banal, repetitive, and dedicated to the celebration of family rites and the consumption of tourist sites.

One can easily understand, therefore, why a select group of practitioners, able to avoid material constraints by their social status and believing themselves to be members of an intellectual "elite," attempted to "place the mechanical image under the aegis of a master . . . with a magical and prestigious name: Art."[2] The fashion became "art for art's sake" and "artists of the soul."

Born in the last decades of the 19th century, the Pictorialist movement spread rapidly, gaining structure and momentum until it virtually dominated the photographic production of the first years of the 20th century. But the movement did not die as the social and artistic system that had produced it disappeared. It instead suffered a slow and progressive paralysis, which only had the effect of accelerating its condemnation by those who had broken from it.

That condemnation was intensified by the emergence of a documentary photography whose motivating force was a search for Truth. For these practitioners and theoreticians, clarity became the principal characteristic of a photographic image,[3] and the manipulation of that image, the soft-focus blur, and the quest for an "artistic style," was considered, at best, a gratituitous "reproducing the effects attained by the painter"[4] and, at worst, a manifestation of the depraved taste of the bourgeois audience of the photographer.

The situation of Pierre Dubreuil is inseparable from this context and he suffered, more than anyone from the general repudiation of the Pictorialist movement. But can we cast the same reprobation on the languid, coquettish nymphs of Constant Puyo, the tempestuous landscapes of Léonard Misonne, and the refined compositions of Pierre Dubreuil?

Such an amalgamation has resulted, first and foremost, from the extended duration of the Pictorialist movement, which led to multiple and heterogeneous tendencies. However, it also derives from Dubreuil's chosen position. An "original," working from the periphery of the movement, he apparently never saw the necessity to disassociate himself from it.

The retrospective exhibition of works by Pierre Dubreuil at the Musée National d'Art Moderne, Centre Georges Pompidou, marks the rediscovery of one of the masters of photography. We are indebted to Tom Jacobson, whose dedication and perseverence has made this exhibition possible.

Dubreuil's work can now speak for itself. And what do we see? Not the suave seductions commonly attributed to the Pictorialists, none of the tricks which seems so artificial, but a sharp

photographic frame, aggressively cutting, isolating fragments of reality—an overt impression of spontaniety and daring tempered by an uncanny sense of construction. It is a precarious position, indeed, but one that engenders an ingenious photographic vision, seemingly timeless, and rarely equalled.

Transcending the nostalgia of an era, Pierre Dubreuil is suddenly revealed as one of the pioneers of a modernity that can sometimes germinate outside the well-tilled soil of the "avant-garde."

Alain Sayag
Curator of Photography
Musée National d'Art Moderne
Centre Georges Pompidou

1. *Du bon usage de la photographie*, CNP, (Paris 1987) p. 9.
2. Marc Melon, "Au delà du réel, la photographie d' art," *Histoire de la Photographie*, (Paris 1986), p. 86.
3. Gisèle Freund, *Photographie et société*, (Paris 1974), p. 89.
4. Jean-Luc Daval, *La photographie, histoire d'un art*, (1982) p. 117.

Preface and Acknowledgements

One night, during a particularly intense research trip to Europe, early on in this project, I had an extraordinary dream. I was being led by someone (I don't know whom) through a small apartment, out a back door, to a garden. I was in a state of great anticipation. As I exited the apartment and turned to the left, there, sitting in a chair on the porch, was Pierre Dubreuil. He did not rise, but greeted me warmly. This was a moment I had long awaited. He appeared just as I had expected: genteel, proud and erect in his chair. In his left hand was a pipe that was lit, but the smoke, curling up in a filigreed pattern, was frozen, fixed as in a photograph. I sat down close to him, our knees nearly touching, and paused to savor the moment. There were so many questions, and now I was to have the answers. I smiled and took a deep breath. And then I awoke.

From the beginning Pierre Dubreuil was an enigma. I had seen a few of his images reproduced in the photographic annuals of the period around 1930, and the more I saw of his bizarre work, the more intrigued I became. It was such a mystery. Who was the man behind these photographs? Where were his prints? Why was he completely unknown to my colleagues? The enigma became my obsession—I was compelled to follow it, step-by-step.

This catalogue, which commemorates the retrospective exhibition of Dubreuil's work at the Centre Georges Pompidou in Paris, is the culmination of an incredible odyssey. It is dedicated respectfully to Pierre Dubreuil, who, despite it all, remains an enigma, triumphantly, to the end.

Many people have contributed to the realization of this catalogue. In Belgium the following people must be thanked: Michael Hocken, Louis and Elizabeth Vanderwaeren, Guido Goyens, Tristan Schwilden, Pool Andries, Roger Coenen, Joseph Peeters, Madame G. Gheude, and Monsieur F. Steenackers. Warm thanks go to the family of Pierre Dubreuil in France, particularly Louis Gerard and Josette Meurillon, and Antoinette Meurillon. Thanks are owed to Robert Delpire, Philippe Néagu and Françoise Heilbrun, and to Serge Bramly. In England Philippe Garner at Sotheby's, Dorothy Bohm at the Photographer's Gallery, and the Royal Photographic Society in England provided greatly valued assistance.

Closer to home, the following people have given support and encouragement: Graham Nash, Kaori Hashimoto, John Ruskin, Weston Naef at the J. Paul Getty Museum, Arthur Ollman at the Museum of Photographic Arts, David Kinney, Joseph Bellows, Suda House, Bob Walker, Philipp Scholtz Rittermann, Neal Todrys, Janet Casey, Naresh Mehra, Karen Black, Graham Howe, Nancy Medwell, Martin Weinstein, Bill Rosen, Jonathan Stein, Bill Rodgers, Beaumont Newhall, David Travis at the Art Institute of Chicago, Christian Peterson at the Minneapolis Institute of Arts, Robert Sobieszek and Janet Buerger at the George Eastman House, Pierre Apraxine at the Gillman Paper Company, Peter Bunnell at Princeton University, Maria Morris Hambourg at the Metropolitan Museum of Art, John Szarkowski at the Museum of Modern Art, Peter MacGill at Pace/MacGill, Gerald Incandela, Naomi Rosenblum, Estelle Jussim, and the late Sam Wagstaff. Special thanks go to John Waddell for his invaluable support.

I would like to express my appreciation to the following people who contributed to this catalogue: Richard Benson, who graciously consented to prepare the negatives for the plate section; Patrick Dooley for his handsome catalogue design; Dinah McNichols and Mark-Elliott Lugo for saving my professional reputation by polishing the essay; David Gardner for his superb printing job; and Alain Sayag and the staff at the Centre Georges Pompidou who helped make this all possible.

Tom Jacobson

A Modernist Among the Pictorialists

*Some say he is a fanatic, an eccentric; others insist that he is one of the rare
photographers who have ideas that will last. Such a contradiction should not surprise us;
it has always been associated with those whose names have become famous in literature
and the arts . . . Yes, Pierre Dubreuil is the subject of violent discussions in our country.
He knows this better than anyone; it does not discourage him . . . Let time do her
work . . Where necessary time honors those stars that are too modest or unknown
and drowns the glorious, arrogant ephemera in shadow and oblivion.*[1]

Cyrille Ménard, 1912

After nearly half a century of oblivion, Pierre Dubreuil has emerged from the shadows.
His reappearance is so startling that the question has to be asked: How could one of the pivotal
Modernists of photography have been forgotten—relegated to such obscurity that few histories
of the medium mention him, even in footnote? The answer can certainly be traced to the
disruptive effects of the two world wars, but in a larger sense it lies in an apparent contradiction;
for while Pierre Dubreuil was emphatically a Modernist (and he was one of the first), he was also,
nevertheless, a Pictorialist—a Pictorialist from beginning to end.

I

AN AMATEUR MOVEMENT The Pictorialist movement began in the last decades of the 19th
century, as technological innovations brought photography within easy reach of the nonprofes-
sional. Amateur photographers who had the means, talent, and ambition, banded together in
elite groups with the express purpose of elevating photography from a craft to an art form. The
Pictorialists, as they were known, designed special lenses to soften the edges of their images and
eliminate what they considered to be the "harsh" details found in the more utilitarian
applications of their medium. They experimented with new printing processes that allowed a
measure of personal intervention: gum bichromate, glycerin-platinotype, oil, and bromoil; and
created exotic, at times extraordinarily beautiful prints that frequently did not look like
photographs at all.

There being no established model for a photographic art, the Pictorialists looked to
traditional fine art disciplines—especially painting and printmaking—for inspiration. Some

created Barbizon or Impressionist-style landscapes. Others produced portraits in the manner of Sargent, Rembrandt, or Hals. A few of the Pictorialists insisted on maintaining the integrity of the photographic process, but most used a variety of unorthodox techniques to reach their artistic goals. Frank Eugene, for example, scratched his negatives with a needle to simulate the incised lines of an etching.

Of the numerous international societies these Pictorialists founded in England, Europe, and the United States, around the turn of the century, none was more vital than the American Photo-Secession. Its dynamic and charismatic leader, Alfred Stieglitz, also published and edited *Camera Work,* the most lavish and influential photographic periodical of the day. The gravure plates featured in this deluxe quarterly were sometimes more beautiful than the photographs they reproduced. *Camera Work* was the foremost showcase of artistic photography and as the arbitor of its contents, Stieglitz was courted by elite photographers from around the world coveting representation there.

No photographer was more influenced by the Photo-Secession than Pierre Dubreuil, who had already come under the spell of the Americans in 1901 when F. Holland Day exhibited *The New School of American Photography* in Paris. Dubreuil followed *Camera Work* closely and, much to the annoyance of his fellow Frenchmen, he adopted the Americans' approach as his own. He saw expressed in their work that which he sought to express in his own: bold and unconventional ideas.[2]

THE ARTIST Pierre Dubreuil was born in the northern industrial town of Lille, France, in 1872. A family-owned wallpaper and interior design business provided financial stability for most of Dubreuil's life, enabling him to pursue the art of photography without commercial constraints.[3] Dubreuil's first recognition came in 1896 when his enigmatically titled *Sombre Clarté* ("Dark Clarity") was shown in Brussels. Later that year, five of his works were accepted by the Photo-Club de Paris, the most prestigious forum of art photography in France.

Within four years, Dubreuil had won international acclaim, at times upstaging even the venerable French masters Constant Puyo and Robert Demachy, who were then dominant figures of the Photo-Club de Paris. In 1900, the *Annuaire Général et International de la Photographie* served as a virtual Dubreuil monograph when it featured 39 of his recent works.

Hailing Dubreuil as a genius, German critic Fritz Loescher wrote in *Photographische Mitteilungen,* "What makes his pictures so outstanding can be summed up in a few words . . . Dubreuil's pictures are 'seen,' seen through the eyes of an artist."[4] Of Dubreuil's print *Morning at the Shore* (fig. 1), circa 1898, Loescher proclaimed, "It is a spontaneous picture, but notice how precise the timing of the right moment is! . . . This is a masterpiece, a pearl among the masses of photographs of the moment."[5]

Few of Dubreuil's works from this early period (1896 — 1900) have survived. Possibly, the photographer himself destroyed them,[6] for just as he had mastered the art of "the decisive moment," he renounced it. He declared, "Chance is the enemy of the photographer."[7] Abandoning the hand camera, he took up the more cumbersome view camera—firmly mounted on a tripod—and became involved in *making* photographs, rather than taking them. "Every

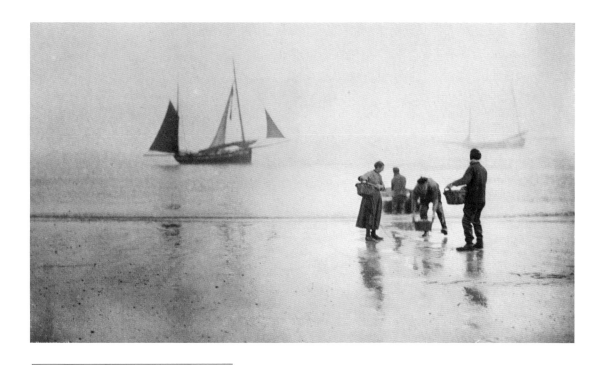

Figure I. Pierre Dubreuil, *Morning at the Shore*, c. 1896

work should be the expression of an idea," he wrote. "This must never be left to chance . . . I plan almost all of my works beforehand."[8]

Later in his career, Dubreuil compared his creative approach to that of a painter. He asked, "Why should the inspiration that exudes from an artist's manipulation of the hairs of a brush be any different from that of the artist who bends at will the rays of light?"[9]

IDEA PICTURES The conceptual elaborateness found in some of Dubreuil's photographs is exemplified by *Les Volants* (pl. 1) of 1901. At first glance, *Les Volants* appears to be a charming indoor study of children at play, in the manner of photographs by Clarence White or Guido Rey. However, closer analysis reveals the artist's mind at work.

Badminton was played with a net. Here, there is no net—or so it would seem. Yet, if one follows the game depicted, that is, the movement from racquet to racquet, the window curtain is amazingly transformed into a net. This visual pull is created partly by the direction of the shuttlecock and is reinforced by the heavy, repeated shuttlecock shape found in the form of the planter. The pull also extends to the racquet on the left, which is drawn more toward the young girl's head than toward the approaching shuttlecock. A metaphor is now complete: the girl, whose dress floats about her like feathers, is herself an upside-down shuttlecock. The photograph plays on the dual meaning of *volant*, i.e., shuttlecock and the flounce of a dress.

Another example of Dubreuil's "idea pictures" is *Frise pour Chambre d' Enfants* (fig. 2), circa 1902. Here, the artist has appropriated the style of a mural decorator. Two girls assume identical poses, but they are seen from different views. One girl has light hair, the other dark. Correspondingly, there are two potted trees, one with light foliage, the other dark. The light tree

Figure 2. Pierre Dubreuil, *Frise pour Chambre d'Enfants*, c. 1902

is seen "in profile" and the dark tree "faces forward." Just as these young trees have outgrown their pots, so the girls have outgrown their chairs.

French critic Ménard, noting Dubreuil's propensity to "shock his viewers," wrote ". . . he pushes an idea to the point of failure. He does so in a way that borders on the riddle, affectation."[10] Dubreuil's puzzles were criticized at that time, but they were to become hallmarks of his style.

THE OIL PRINTS To the Pictorialist, the print was of utmost importance and as a Pictorialist, Dubreuil was committed to making stunning prints. His ideas may have been controversial, but his formidable technique was never questioned. He deliberately tackled problems of lighting, contrast, and tonal reproduction to demonstrate his technical virtuosity.

Dubreuil experimented with various printing processes, including carbon, platinum, and gum, but in 1904, he found the process that was to serve him well for the rest of his career. Robert Demachy described the Rawlins oil process to *Camera Work* readers in 1906:

> Photographers are supposed to know that a thin layer of bichromated gelatine, when exposed to light, in contact with and under a glass negative, will shortly develop a brown image which, once plentifully washed and then dabbed with a blotting paper, will show a faint relief, and a curious difference between the exposed and protected portions. These last will be damp and shiny, while the others matt and relatively dry . . . If a layer of greasy, colored ink is spread over the damp film, it will stick to the matt parts and be repelled by the moist ones—a positive image will result.[11]

Through a "hopping"—or dabbing—action, ink was applied to the print with a stencil

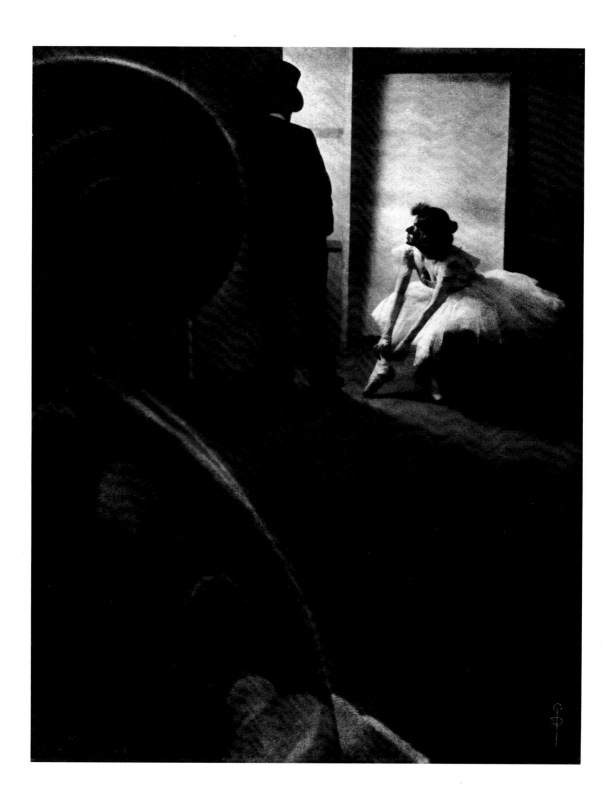

Figure 3. Pierre Dubreuil, *Behind the Scenes,* 1902

brush. The photographer could darken and lighten portions of the image at will. Contrast could also be controlled by the consistency of the inks used, and Dubreuil sometimes employed more than one ink on the same print, to strengthen the shadows, for example. He was to become perhaps the greatest practitioner of this versatile and permanent process.[12]

THE LINKED RING In 1903, Pierre Dubreuil was elected to the venerated British photographic society, The Linked Ring. He was now on the highest rung of the Pictorialist ladder, joining such luminaries as Stieglitz, Edward Steichen, F. Holland Day, Frederick H. Evans and Gertrude Käsebier. He was not elected without some hesitation, however. A few "Links" felt that Dubreuil was still groping, flexing his pictorial muscles, rather than making truly personal statements.[13]

Within a few years, Dubreuil had earned a reputation among conservative factions of the movement as ". . . a crank, a man striving after effect at all hazards, appealing to the mere bizarre and unusual, in order to make a sensation . . ."[14] He remained indifferent to these attacks from the insular photo world and instead drew inspiration from progressive movements in other fine art disciplines.

Apparently, Dubreuil had been following the artistic developments taking place in Paris and by 1908 that city's lure proved irresistible. Having recently separated from his wife,[15] Dubreuil was at liberty to take an extended artistic sojourn. He arrived in Paris at a critical juncture in the history of modern art—during the birth of Cubism and the manifestos of the Futurists. The milieu was intoxicating and Dubreuil's art flourished.

PARIS: 1908 – 1910 Surprisingly few European Pictorialists were affected by the artistic revolution fomenting in Paris; certainly the Frenchmen Demachy and Puyo were not swayed. Dubreuil, however, was as full-blown a Modernist as a Pictorialist could be.

During his two-year stay in Paris, Dubreuil created audacious new works that advanced the evolution of photography. These were among the first expressions of Modernism in photography.[16] Many of the Modernist developments of the 1920s—the close-up, bird's-eye and worm's-eye views, and montage—were explored by Dubreuil from 1908 to 1910. But his subject matter also distinguished him as a Modernist, for while most Pictorialists focused softly on the romance of the past, avoiding incursions of the machine age in their idyllic, pastoral scenes, Dubreuil was a man enraptured with the possibilities of the modern age.

Art critic Robert Hughes has written, "For the French, and the Europeans in general . . . the master image, the one structure that seemed to gather all meanings of modernity together—was the Eiffel Tower."[17] Dubreuil was perhaps the first artist to seize this symbol, in Eléphantaisie (pl. 2) of 1908.[18] Ingeniously distorting both scale and perspective, he played the old against the new: the elephant, struggling against its earthly chains, seems to herald the dawn of the new age.

The photo world was shocked when Eléphantaisie was exhibited in London in 1910.[19] A critic suggested,

> [Dubreuil] should have accompanied Mr. Roosevelt to the end of the equatorial forest;

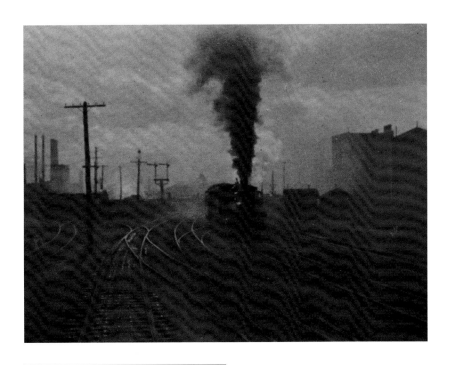

Figure 4. Alfred Stieglitz, *The Hand of Man,* 1902

Figure 5. Pierre Dubreuil, *Mightiness,* 1909

he could have photographed big game, instead of this golden bronze junk that is barely acceptable among the bushes and flower beds of a public square but is a challenge to common sense on the walls of an exhibition.[20]

Dubreuil explored another great Modernist icon, the automobile, in his *Les Boulevards* (pl. 7) of 1909. Here, he boldly focused in on the taxi meter, emphasizing the ironic "libre" sign, pointing wittily to the horseless carriage to which it is attached. Critics were confounded by such pictures. *The British Journal of Photography* complained, "Many of his Parisian views would be charming things, did he not spoil them by cutting them across with ungainly foreground objects."[21]

AN APPROACH TO STIEGLITZ Realizing the significance of his new work, Dubreuil made a bold move. On returning to his family in 1910, he sent 12 prints to Alfred Stieglitz in New York, asking that they be considered for reproduction in *Camera Work.*[22] Unaccountably and unbeknownst to Dubreuil, these prints were instead submitted to the jury for the Open Section of the *International Exhibition of Pictorial Photography,* an exhibition that was to be held later that year at the Albright Gallery in Buffalo, New York.

The Albright exhibition was a monumental retrospective survey of the entire Pictorialist movement, as seen through the eyes of Stieglitz. Although most of the works were included by his invitation, Stieglitz devised an Open Section to counter any charges of autocracy. The jury, composed of Stieglitz, photographer Clarence White, critic Charles Caffin, and painter Max Weber, chose six of Dubreuil's prints[23] (including plates 2, 5, 6, 8, 9) for inclusion in this landmark exhibition.

An outspoken review of the Albright exhibition by critic F. Austin Lidbury, published in *American Photography,* concluded that the juried Open Section was somewhat of a mistake and contained too many works that were not above the standards of the average camera club. But, Lidbury found one of the "joy spots" of the exhibit to be ". . . the six extraordinarily interesting examples of Dubreuil's original, if distorted way of looking at things."[24]

SOME COMPARISONS Dubreuil's "distorted way of looking at things" can be examined within its context by comparing three of his works from the Albright exhibition with those of his contemporaries. In the first two cases, the work of the other artist was also shown in Buffalo in 1910.

Dubreuil had probably seen Stieglitz's *The Hand of Man* (fig. 4) when it was reproduced in *Camera Work* in 1903. But where Stieglitz captured an environment, Dubreuil, in his *Mightiness* of 1909 (fig. 5), concentrated on an abstract force of steel and steam. Another, later, print from the same negative,[25] *Interpretation Picasso: The Railway,* (fig. 6), circa 1911, is more obviously Cubist-inspired; but *Mightiness* is also Cubistic, in that it shows two viewpoints of the same object simultaneously. The locomotive enters the picture on a diagonal, but the front of the engine is visually askew—nearly jumping out of the picture plane.

Alvin Langdon Coburn's 1907 *Notre Dame* (fig. 7), is interesting mainly because it focuses on the secondary motif of the leaves. Dubreuil has taken this idea to an extreme in his 1908 *Notre*

Figure 6. Pierre Dubreuil, *Interpretation Picasso: The Railway*, c. 1911

Dame de Paris (fig. 8), amplifying it into a jarring distortion. Actually, no chestnut trees existed at this location—this is a photo montage. Dubreuil printed the life-size chestnut leaves from another negative.[26] When this picture was shown in London, a critic asked, ". . . Of course, the view of the cathedral may be good or charming—but who can see it or appraise it between and beneath the chinks of these black masses?"[27]

Coburn's work of 1912, *The Octopus*, (fig. 10) has long been regarded as a "first" in modern photography. As he explained in his autobiography, "Depending as it does more upon pattern than upon subject matter, this photograph was revolutionary in 1912."[28] Ironically, after seeing Dubreuil's 1908 *Grand Place* (fig. 9) at the London Salon in 1911, one critic wrote, "M. Dubreuil is to be congratulated on capturing it. It is the sort of thing that . . . would have been patiently worked out by Coburn. Not many others would have been likely to see it . . ."[29]

A REBUFF In 1912, Dubreuil made another, albeit more roundabout, attempt to have his photographs reproduced in *Camera Work*. Learning that Stieglitz was forming a private collection of photographs, many of which had been shown at the Albright Exhibition, Dubreuil generously, but certainly not without ulterior motives, sent Stieglitz a gift of five of his most important prints. He wrote:

> *Dear Sir:*
>
> *I am informed that you are in possession of a collection of photographs, which have been exhibited in the Albright Art Gallery at Buffalo during 1910 and caused such admiration. As you had the kindness to show some of my prints [in] this salon for which accept my sinceres (sic) thanks, I am taking the liberty of forwarding you five oil print originals to add to your collection.*
>
> > *Yours faithfully*
> > *Pierre Dubreuil*
>
> *List of Photographs by Pierre Dubreuil*
>
> ———————
>
> "Notre Dame de Paris"
> "Eléphantaisie"
> "Grand Place Brussels"
> "Mightiness"
> "Cascade, Place de la Concorde" [pl. 4][30]

These five prints have not survived in the Stieglitz collection and their fate is unknown.[31] Evidently, Dubreuil's ploy was not effective, for when Stieglitz highlighted the work from the Open Section of the Albright exhibition in a 1912 issue of *Camera Work*, he again ignored Dubreuil and instead featured newcomer Karl Struss. Struss seems to have responded to Dubreuil's work, however. His *Eiffel Tower with Elephant* (fig. 12), dated 1925, was produced some 15 years after seeing Dubreuil's *Eléphantaisie* at the 1910 Buffalo exhibition.[32]

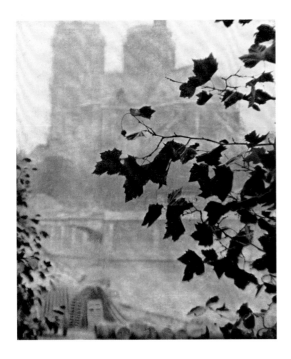

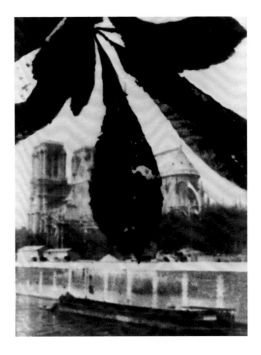

Figure 7. Alvin Langdon Coburn, *Notre Dame,* 1907

Figure 8. Pierre Dubreuil, *Notre Dame de Paris,* 1908

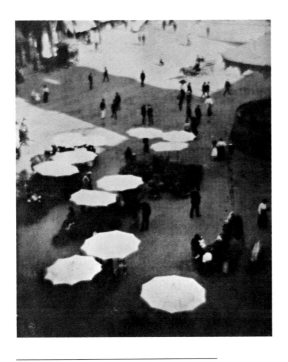

Figure 9. Pierre Dubreuil, *Grand Place, Brussels,* 1908

Figure 10. Alvin Langdon Coburn, *The Octopus,* 1912

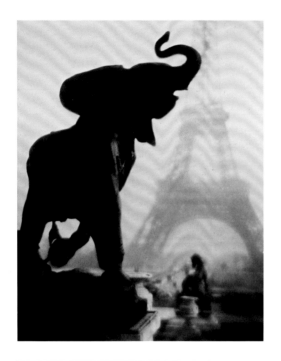

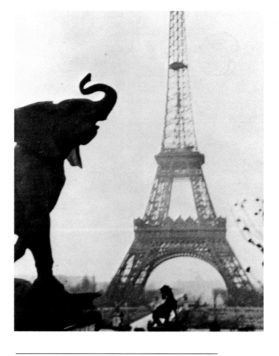

Figure II. Pierre Dubreuil, *Eléphantaisie*, 1908

Figure I2. Karl Struss, *Eiffel Tower with Elephant*, 1925

More than one critic has been struck by the distance between Stieglitz's avant-garde stance and the photography he featured in *Camera Work*. In his book *Creative Photography*, Helmut Gernsheim wrote,

> Stieglitz's artistic perception was far in advance of that of his contemporaries and made him the greatest protagonist of modern photography and modern art in the United States. It must be admitted that whilst the work of the artist still looks modern today, that of the photographers is—with few exceptions—dated. The illustrations in Camera Work prove that the majority of Stieglitz's followers fall short of his ideals, and one is sometimes puzzled how he could possibly have accepted their work so wholeheartedly.[33]

PAUL STRAND It was not until 1916, with the appearance of Paul Strand, that photography seems to have come of age in *Camera Work*. Strand has thus been credited with singlehandly pushing photography into the modern era,[34] but Dubreuil's work, preceding Strand's by seven or eight years, suggests that the entire story has not been told.

In 1912, Strand received his first international recognition when his photograph *The Garden of Dreams* (fig. 13) was accepted by the prestigious London Salon. In a review of the salon that year, F. C. Tilney compared Strand's photograph with a work by Dubreuil:

> The Garden of Dreams *by Paul Strand, with its temple and still waters, partakes of the romance of rococo, and as such is entirely successful. Pierre Dubreuil's* La Fontaine de Carpeaux au Luxembourg *ought to do still more; but somehow, its associations*

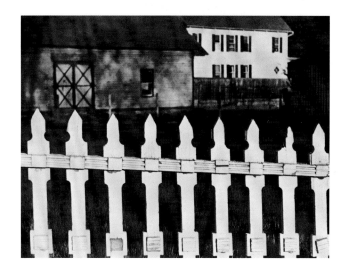

Figure 13. Paul Strand, *The Garden of Dreams*, 1912

Figure 14. Paul Strand, *White Fence*, 1916

are rather those of silk hats than three-cornered ones; more of motor cars than sedan
chairs. Both selection and presentation are absolutely photographic, as no doubt
M. Dubreuil intended they should be. He is a modernist among the moderns . . .[35]

Strand resolved the tensions of his subject and created a typical Pictorialist photograph. Dubreuil, in his *La Fontaine de Carpeaux* of 1912 (pl. 12), exploited the tensions of his subject to express an idea. He pitted the fountain's arcing spray against the curves of the horses' legs, playing photographically arrested movement against sculpturally arrested movement.

A ONE-MAN SHOW A one-man show in 1912 at the London gallery of the *Amateur Photographer* reinforced Dubreuil's position as a Modernist. Sixty-four works were arranged chronologically to document the photographer's dramatic evolution. Reviewing the exhibition, Anthony Guest wrote,

> It is useful to note how the pioneer impulse, which has been experimenting, searching,
> and attempting surprising things in Paris, has touched the photographic outlook of
> M. Pierre Dubreuil . . . The old paths, it seems, are growing too familiar for the
> modern spirit. The idea that you must arrest the beholder suddenly, violently,
> even brutally . . . influences this collection.[36]

Finding some of the work unintelligible, Guest complained,

> La Place de la Concorde *is really a picture of a part of a balustrade, but close inspec-*
> *tion reveals small glimpses of the Place between the little pillars. I do not think any*

artistic purpose is served in this way . . . The view, nearly hidden by stonework, is
scarcely worth a pictorial record.[37]

Dubreuil's *La Place de la Concorde* (pl. 3) of 1908 can be viewed as a precursor to Paul Strand's famous *White Fence* (fig. 14) of 1916. In that seminal photograph, Strand clearly broke with Pictorialist tradition. He flattened the picture space and created a composition that borders on abstraction. Dubreuil's work retains the softness of edge and atmospheric space of Pictorialism. But *his* photograph, with its bold viewpoint and formal emphasis, was arguably more radical in 1908 than Strand's was in 1916.

A CAREER INTERRUPTED How Dubreuil would have evolved by 1916 will never be known, because his career was disrupted in 1914 with the outbreak of World War I. He was conscripted into the Army Service Corps as an ambulance driver and was cut off from his family in Lille when German troops occupied the northern provinces. Soldiers, searching for the famous photographer, looted his house, stealing all of the photographic equipment his wife had not hidden.[38]

At the end of the war, disaster struck again. One of Dubreuil's daughters died in the influenza epidemic of 1918 and his wife died three years later. Perhaps to put tragedy behind him, Dubreuil left Lille and settled in Brussels, where he remarried. He did not re-emerge in the photo world until 1923. During an absence of nearly a decade, great changes had taken place. The "Golden Age" of Pictorialism was over and the Late Pictorialist period was well under way.

II

THE LATE PICTORIALISTS Historians have not looked kindly upon the Late Pictorialists.
Scholarly interest in the movement has traditionally ended with the demise of the Photo-
Secession in 1917. The Pictorialist movement continued well into the 1920s and 1930s, but by
then it had lost much of its cutting edge. Many of the greatest talents of the earlier period were
gone. Some, like Steichen and Baron deMeyer, had moved on to the commercial sphere.
Stieglitz, no longer in control, abandoned the movement completely.

Although the mechanisms of Pictorialism were firmly in place, with exhibitions and
publications proliferating, the movement had become too democratized. It was compromised
by a preponderance of mediocre talent. Revisionist historians are now recognizing some ex-
ceptional artists, however, such as Frantisek Drtikol, Jaromir Funke, Hugo Erfurth, and
Josef Sudek,[41] who were leading a progressive direction within the Pictorialist movement.
This direction de-emphasized evidence of the artist's hand and stressed clarity, hard edge, and
bold design.

Dubreuil was at the forefront of the Modernist faction of the Late Pictorialist movement.
He decried the "deplorable banality" of most works shown in the salons, where "the process is
all-important, the artistic idea nonexistent, and of course, originality even less."[42] He wrote,

> *In photography, a much greater importance should be given to the intellectual aspect of
> the work. Indeed, it should become the main artistic factor. Isn't it the intellectual work
> that is responsible for creating the feelings we experience in the presence of a master-
> piece? Isn't it thanks to this that an intense communion between author and viewer can
> be achieved?*[43]

LATE INFLUENCES Ever receptive to new ideas, Dubreuil continued to incorporate the
trends of modern art into his own work and, by the late 1920s, his name had become

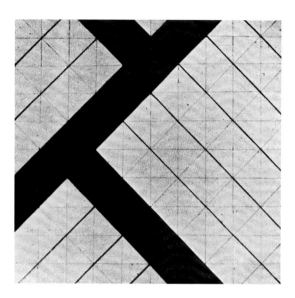

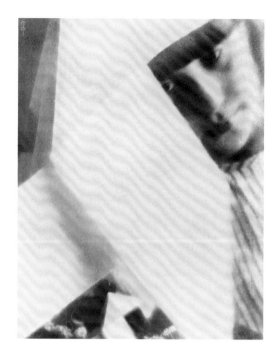

Figure 15. Theo van Doesburg, *Counter-composition*, 1925 Figure 16. Pierre Dubreuil, *Dudule*, c. 1927

synonymous with the Modernist school of photography in Belgium. The Surrealist movement is clearly evident in his work (see figs. 22 & 24). He seems to have turned away from the real world and retreated into a realm of fantasy and dream. From the great Belgian artist James Ensor,[44] he derived a passion for the carnival mask which can be seen as a symbol of his change of identity from Frenchman to Belgian.

The de Stijl movement in Holland might seem incompatible with Belgian Surrealism, but Dubreuil took his ideas wherever he found them.[45] In *Dudule* ca. 1927 (fig. 16), he appears to have appropriated the abstract design of Theo van Doesburg's *Counter Composition 1925* (fig. 15) as a schematic for his own composition. Dubreuil created a poetic metaphor based on scale, the flowers relating to the girl in a fantasy that would probably have been antithetical to the reductive aims of van Doesburg.

A DECEPTIVE WORLD Daring use of scale is an important characteristic of Dubreuil's late work. He created a close-up world where ordinary objects play against each other in surprising ways. In *Concombres* ca. 1930 (fig. 17), for example, Dubreuil presents a puzzle to the viewer. Something is disturbing: either the cucumbers are unusually large or the fork is too small.

Deceptions and ambiguities abound in his pictures. The girl in *Les Quilles* of 1928 (pl. 23) appears to be playing the game but, in fact, the viewer is the player. Men look like women in *Aviator* of 1929 and women look like men in *Woman Driver* of 1928 (fig. 19). The man in *Sprint*, ca. 1932, (fig. 18) seems to be a competition cyclist, but closer study reveals a hand deformed by arthritis and a face that is aged. It is a "sprint," i.e., an acceleration before the end, that is depicted.

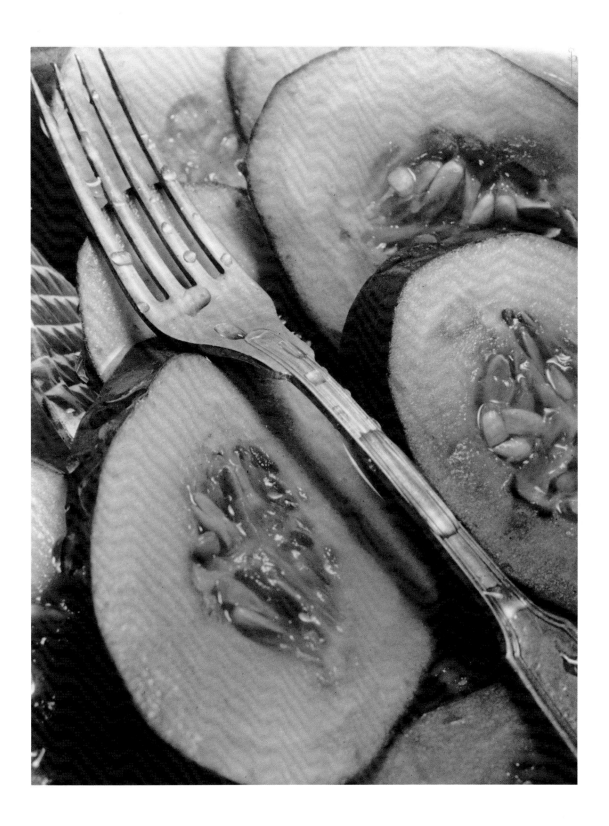

Figure 17. Pierre Dubreuil, *Concombres*, c. 1930

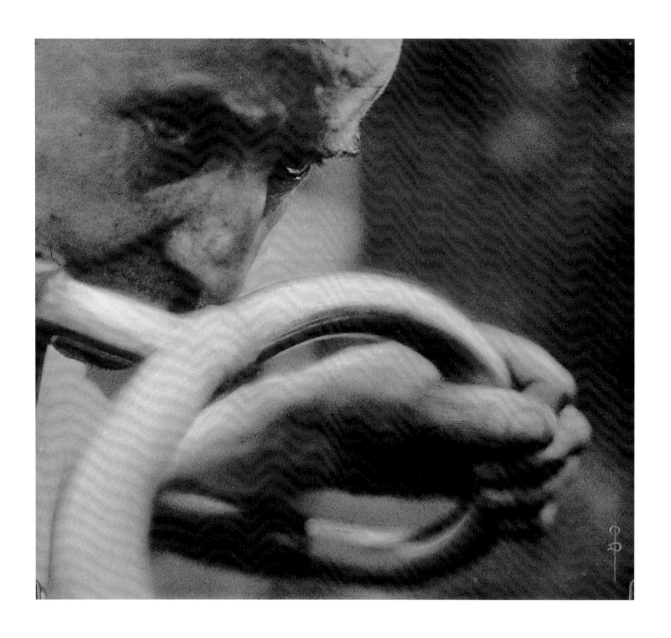

Figure 18. Pierre Dubreuil, *Sprint,* c. 1932

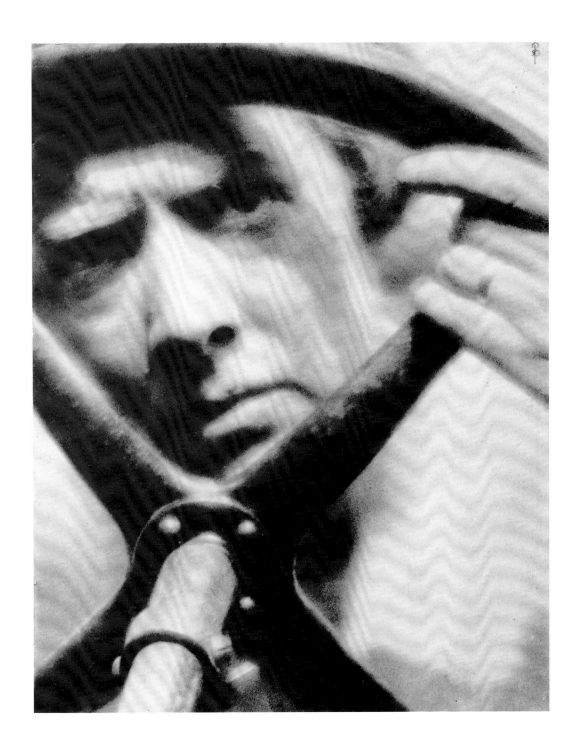

Figure 19. Pierre Dubreuil, *The Woman Driver*, 1928

Many pictures can be understood only by referring to their titles. *Instruments des Parques*["Tools of the Parcae"] ca. 1932, (fig. 20) alludes to the three Fates of Roman mythology, the daughters of Night who spun and then cut the thread of life. The objects shown relate in obvious ways to the title, but it is the three unseen sources of light from above that make the image so extraordinary.

At times Dubreuil's ideas were so subtle, so obliquely expressed that audiences accustomed to the clichés of Late Pictorialism missed his point completely. When his works were shown yearly in *Photograms of the Year* from the 1920s to the 1930s, they were frequently greeted with derision. In the commentary accompanying the illustrations, Dubreuil was referred to alternately as an "eccentric"[46] and an "irresponsible and wayward genius."[47] Discussing *Puppets* ca. 1930 (frontispiece), a self-portrait, a reviewer called it a "characteristic example of the work of the licensed humorist of photography, Pierre Dubreuil, who . . . provides an instance of his freakishness and something to puzzle us with speculation as to his motive."[48]

THE LONDON SALON After the demise of the Photo-Secession and the Linked Ring, the London Salon became the most highly regarded artistic photography society in the world. Dubreuil was closely associated with the society from its inception in 1910, and he reserved his best work for its yearly exhibition.

A discussion by photograper Herbert Lambert, as reported in *The Photographic Journal* in 1931, revealed Dubreuil's unique position in the Pictorialist movement. Lambert pointed out that the London Salon tended to encourage more adventurous work than the rival Royal Photographic Society.

> [He] gave as an instance the curious prints sent in [to the London Salon] each year by Pierre Dubreuil. It was quite possible that such prints would not be hung in the Royal Photographic Society's exhibition, but they were to him intensely interesting and remarkable instances of individual work. In every print which this worker submitted, one could discern the individual mind behind it. In addition to that, they were all of them magnificent prints . . . The selection committee of the London Salon was quite unrepentant about Dubreuil.[49]

A "SPRINT" By 1935, Dubreuil had attained such stature that even the Royal Photographic Society was compelled to recognize his achievements and it sponsored a retrospective exhibition of the 63-year-old photographer. Reviewing the exhibition, J. Dudley Johnston acknowledged Dubreuil's position as a pioneering modernist. He wrote,

> To the present-day photographer, the name of Pierre Dubreuil . . . stands for one of the extremists of photography . . . he is one of the three to whose influence and example the development of the "New Photography" is to be traced, the others being Malcolm Arbutnot in England and Paul Strand in America.[50]

A measure of Dubreuil's precosity was that many works from his earlier period were still considered quite modern in the late 1930s.[51] In 1937, *Vogue* magazine reproduced a work of 1902,

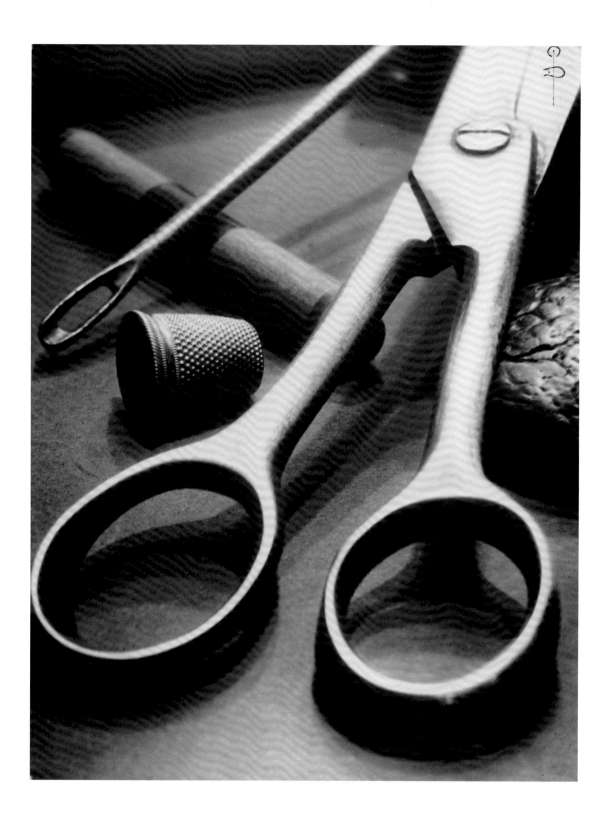

Figure 20. Pierre Dubreuil, *L'Instrument des Parques*, c. 1932

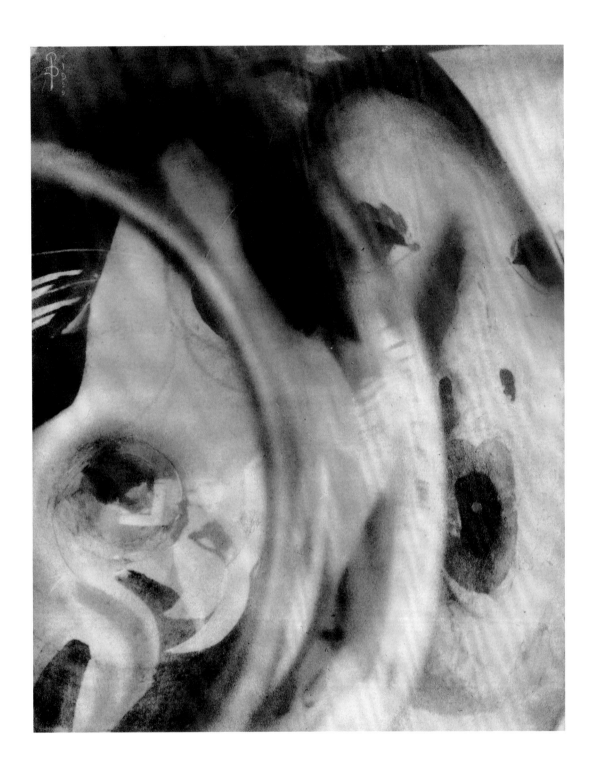

Figure 21. Pierre Dubreuil, *Chantecler*, 1929

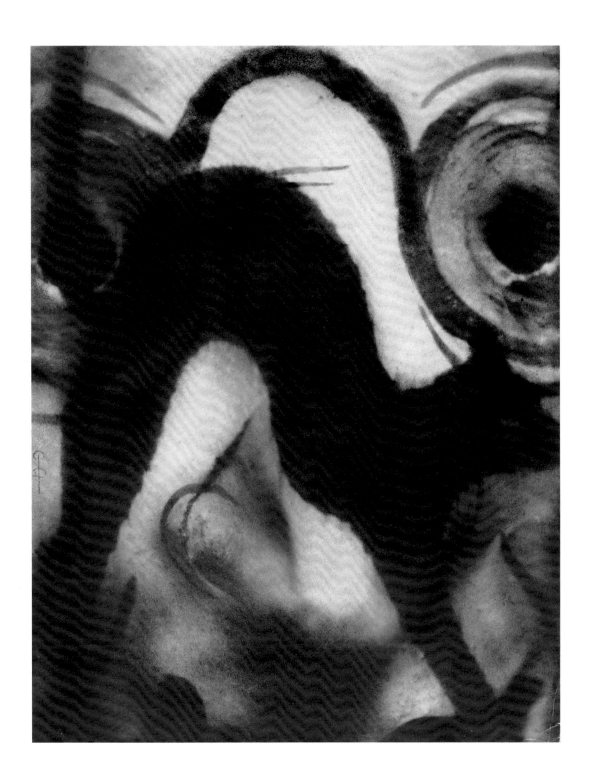

Figure 22. Pierre Dubreuil, *Au Chat Noir,* 1929

Behind the Scenes (fig. 3). The following comments were offered:

> *Although it looks exceedingly modern—partly because of the compositional device of the cello in the foreground—it was photographed long before the moderns were influenced by close-ups in Russian movies: Pierre Dubreuil was merely influenced by Degas and his butterfly ballet-girls.*[52]

Dubreuil remained active in the photographic world as president of the Association Belge de Photographie, but seems to have produced little new work after 1935. By the onset of World War II, his health and finances had steadily deteriorated. Concerned over the preservation of his photographic archives and desperate for financial remuneration, Dubreuil sold his negatives (and probably a sizable portion of his print collection, with supporting documentation) to the Gevaert photographic company in Mortsel, Belgium. Ironically, all of these materials were completely destroyed, still packed in their shipping crates, when the Gevaert factory was bombed during the war.[53]

After the death of his second wife in 1943, Dubreuil, alone and nearly destitute, was sent by the Red Cross to Grenoble, France, where he was cared for by his estranged daughter. A few months later, early in 1944, he died there in total obscurity.[54]

EPILOGUE World War II dealt a devastating blow to the Pictorialist movement, one from which it would never recover. After the war, a new generation of photographers and historians arose who denounced the movement and Pictorialism became an anathema. The entire output of Late Pictorialism was repudiated—the remarkable achievements of Pierre Dubreuil buried alongside the very banalities he deplored.

Dubreuil was undoubtedly one of the most controversial and misunderstood photographers of his day. Despite vilification by his contemporaries, he was undeterred—sustained by an extraordinary self-confidence and vision. In a 1930 article entitled "Le Caractère Personnel" Dubreuil proffered the following manifesto, which will serve here as a fitting epitaph:

> *"Does society understand the precursor? Not at all! Any work with a personal character appears monstrous to it. Innovators worry and ruffle it. . . . Whatever his tool, keyboard, pen, or brush, the artist is never of his time. Sometimes several generations must pass before his efforts take on their true significance. . . . But, what is to be done? . . . Despise dogma. Reject banality. Thirst for the unattainable. . . . Look with your own eyes; feel with your own heart; anxiously search your own soul, and always be ready to answer its deeply felt calls. . . . Escape, and once liberated, run straight ahead, bare-headed, into the sun!"*[55]

Tom Jacobson, 1987

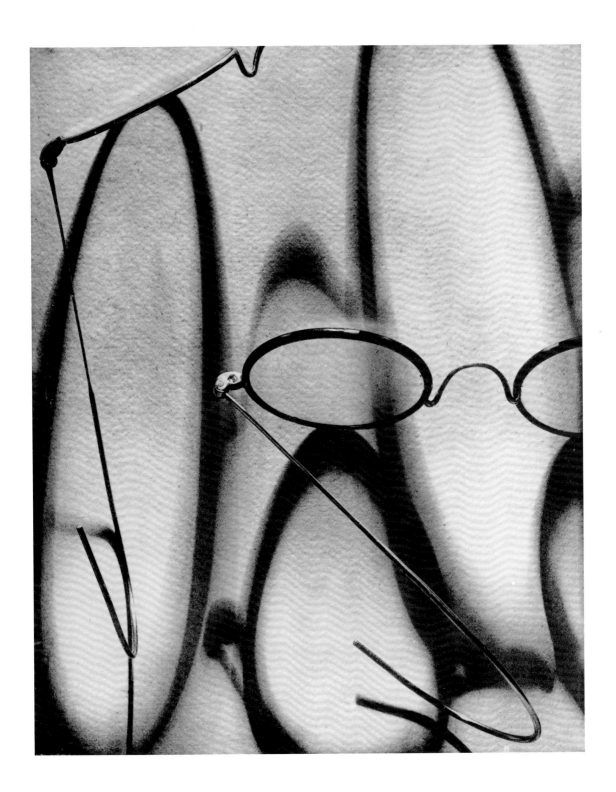

Figure 23. Pierre Dubreuil, *Spectacles*, c. 1929

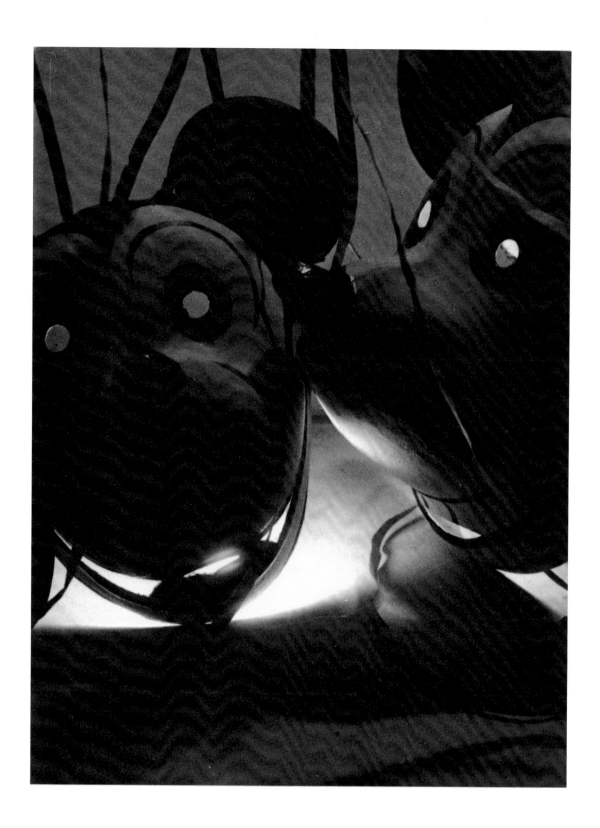

Figure 24. Pierre Dubreuil, *Mickey,* c. 1932

Notes

1. Cyrille Ménard, "Les Maîtres de la Photographie," *Photo Magazine*, no. 18, (1912), pp. 130 & 131.
2. Ibid., p. 150
3. In a manuscript biography of Pierre Dubreuil (collection of author) Jean Thilliez, his nephew, estimates Dubreuil's fortune at over $200,000 in 1910. The Dubreuil firm prospered along with the growth of the textile industry in Lille at the end of the 19th century.
4. Fritz Loescher, "Zu den Bildern von P. Dubreuil," *Photographische Mitteilungen*, (Jahrgang 38, 1901), p. 215.
5. Ibid., p. 216.
6. It is also possible that these prints were destroyed along with Dubreuil's negatives. See note 53.
7. Cyrille Ménard, op. cit., p. 156.
8. Ibid.
9. Pierre Dubreuil, "Le Caractère Personnel," *Association Belge de Photographie*, Bulletin no. 7, (July 1930), p. 54.
10. Cyrille Ménard, op. cit., pp. 137 & 138.
11. Robert Demachy, "My Experience of the Rawlins Oil Process," *Camera Work*, no. 16, (October 1906), p. 17.
12. Since there is no silver in the process, the prints are not subject to fading.
13. Margaret Harker, *The Linked Ring*, (London, 1979), p. 89.
14. American Photography Magazine, (June 1912), p. 359.
15. Revealed in a conversation between the author and Jean Thilliez.
16. Accounts vary, but Alvin Langdon Coburn's "The Octopus" (1912) has been considered by some as the first Modernist photograph. Paul Strand's work of 1915 — 1917 is usually cited as the first body of Modernist work. Stieglitz's "Steerage," although taken in 1907, was not shown until 1910, and there is question as to whether Stieglitz realized its importance until then. The Italian Futurist, Anton Guilio Bragaglia produced very striking Modernist works in 1911. J. Dudley Johnston has cited Malcolm Arbuthnot's work, but it has apparently not survived. See note 50.
17. Robert Hughes, *The Shock of the New*, (New York, 1981), p. 9.
18. Robert Delaunay's "La Tour Rouge" was not begun until 1909. Hughes credits it as the first use of the tower in a substantial way in a work of art. See note 17.
19. J. Dudley Johnston, "Exhibitions at Russell Square," *The Photographic Journal*, (August 1935), p. 462.
20. *Photo Magazine*, (1910), p. 52.
21. *British Journal of Photography*, (March 15, 1912), p. 201.
22. Connecticut, New Haven. *Collection of American Literature*, Beinecke Rare Book and Manuscript Library, Yale University. Hereafter referred to as YCAL. Pierre Dubreuil to Alfred Stieglitz, January 10, 1910. The prints sent to Stieglitz were: "Notre Dame"; "Eléphantaisie"; "The Fountain"; "Le Panthéon"; "La Place de la Concorde"; "Vapeur, gare du Nord" ("Mightiness"); "The Looking Glass"; "Grand Place, Bruxelles"; "The Little Maiden"; "Le Béguinage"; "Portrait"; and "Pte. Place de Province."
23. Catalogue of the International Exhibition of Pictorial Photography, The Buffalo Fine Arts Academy, 1910. The prints shown were: #510 "Steam—Gare du Nord"; #511 "Place de Province"; #512 "The Beguinage"; #513 "Grand Place—Brussels"; #514 "Notre Dame de Paris"; #515 "Eléphantesia" (sic).
24. *Camera Work*, vol. 33, (January 1911), p. 70.
25. If this picture is rotated counter clockwise 45 degrees, the underlying image is the same as "Mightiness."
26. Related in conversation to the author by Jean Thilliez.
27. *The British Journal of Photography*, (September 15, 1911), p. 700.
28. Alvin Langdon Coburn, *An Autobiography*, (New York 1966), p. 84.
29. H. Snowden Ward, "Landmarks of the Year," *Photograms of the Year* (1910/11), p. 55.
30. YCAL, Pierre Dubreuil to Alfred Stieglitz, January 27, 1912.
31. In 1933 the Stieglitz Collection was gifted to the Metropolitan Museum of Art in New York. Duplicates that were in the collection were given to the Art Institute of Chicago. Neither of these collections have any record of the five prints Dubreuil sent to Stieglitz. Since Du-

breuil's correspondence has not been found, and we must go only on the letters from him to Stieglitz, the true story of these prints may never be known.

32. "Eléphantaisie" was exhibited alongside Struss' work in the Open Section of the Albright Exhibition. It can be assumed that Struss, a New Yorker, attended the exhibition, since this was his most important showing to that date, and he was represented by 12 prints.

33. Helmut Gernsheim, *Creative Camera: Aesthetic Trends 1839 — 1960,* (New York 1962), p. 145.

34. In *Photography: A Facet of Modernism* (New York 1986), Van Deren Coke states that Paul Strand, ". . . was the earliest to incorporate modern concepts of form into his work." p. 10.

35. *Photograms of the Year* (1912), p. 20.

36. Anthony Guest, "The Work of M. Pierre Dubreuil at the 'A.P.' Little Gallery," *The Amateur Photographer and Photographic News,* (March 18, 1912), p. 295.

37. Ibid.

38. From a conversation between the author and Antoinette Meurillon.

39. Nancy Newhall, *P. H. Emerson: The Fight for Photography as a Fine Art,* (New York 1975), p. 121.

40. Helmut Gernsheim, op. cit., p. 145.

41. Other Pictorialists who could be mentioned here are Johan Hagemeyer, D. J. Ruzicka, Ira Martin, and the Japanese Americans in the U.S.; John Vanderpant in Canada; Willy Zielke in Germany.

42. Pierre Dubreuil, "La Deuxième Salon International d' Art Photographique," *Photographie Moderne,* (May 15, 1928), p. 49.

43. Pierre Dubreuil, "Intellection," Catalogue: 9th International Kerstsalon, Salon de Noël (1935/36), unpaginated.

44. Dubreuil had probably been made aware of Ensor's work through his contact with the painter Edmond Jamois at the turn of the century. Dubreuil was sometimes referred to as "the Ensor of photography" in the Bulletin of the Association Belge de Photographie.

45. Cyrille Ménard, op. cit., p. 150. Dubreuil defended this approach by citing the precedents of Shakespeare and La Fontaine.

46. *Photograms of the Year* (1932), p. 13.

47. *Photograms of the Year* (1934 — 5), p. 11.

48. *Photograms of the Year* (1931.), p. 14.

49. "Pictorial Photography," *The Photograph Journal,* (December 1931), p. 455.

50. J. Dudley Johnston, "Exhibitions at Russell Square," *The Photographic Journal,* (August 1935), p. 462.

51. Dubreuil apparently took pleasure in exhibiting his earlier works, undated, in the 1930s. For example he exhibited "Mightiness" (1909) at the 21st Annual International Salon of Pictorial Photography, held by the Camera Pictorialists of Los Angeles, in 1938.

52. *Vogue,* (November 1, 1937), p. 94

53. Letter from A.H.S. Craeybeckx to Dr. L. Roosens (May 1968). Collection Provinciaal Museum, Antwerp.

54. No word was sent to Belgium when Dubreuil died, and his date of death was not known until recently. In 1947 he still appeared on the roster of the honorary members of the Camera Pictorialists of Los Angeles.

55. Pierre Dubreuil, "Le Caractère Personnel," *Association Belge de Photographie,* Bulletin no. 7, (July 1930), p. 55.

FIGURE AND PLATE SOURCES: fig. 1, *Annuaire Général et International de la photographie,* 1903, p. 392; fig. 4, *Camera Work,* (Jan. 1903), courtesy J. Paul Getty Museum, Malibu; fig. 7, *Camera Work* (Jan. 1908), courtesy J. Paul Getty Museum, Malibu; fig. 10, courtesy International Museum of Photography, George Eastman House, Rochester; fig. 13, *The Amateur Photographer,* (Jan. 1913), p. 5; fig. 14, *Camera Work,* (June 1917), courtesy J. Paul Getty Museum, Malibu; fig. 15, *De Stijl VII,* (1927), p. 78; fig. 20, courtesy Graham Nash Collection, Los Angeles; plates 6&7, courtesy Metropolitan Museum of Art, New York.

Plates

1. *Les Volants,* 1901

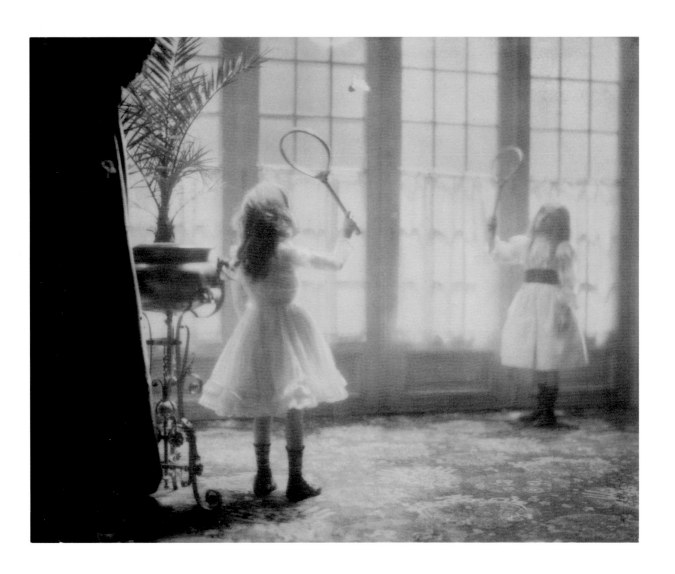

2. *Eléphantaisie,* 1908

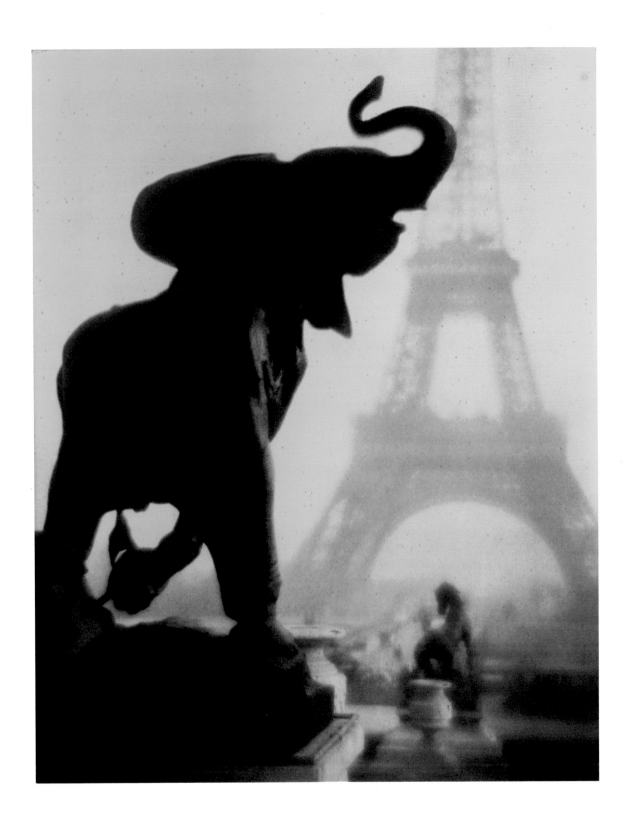

3. *La Place de la Concorde*, 1908

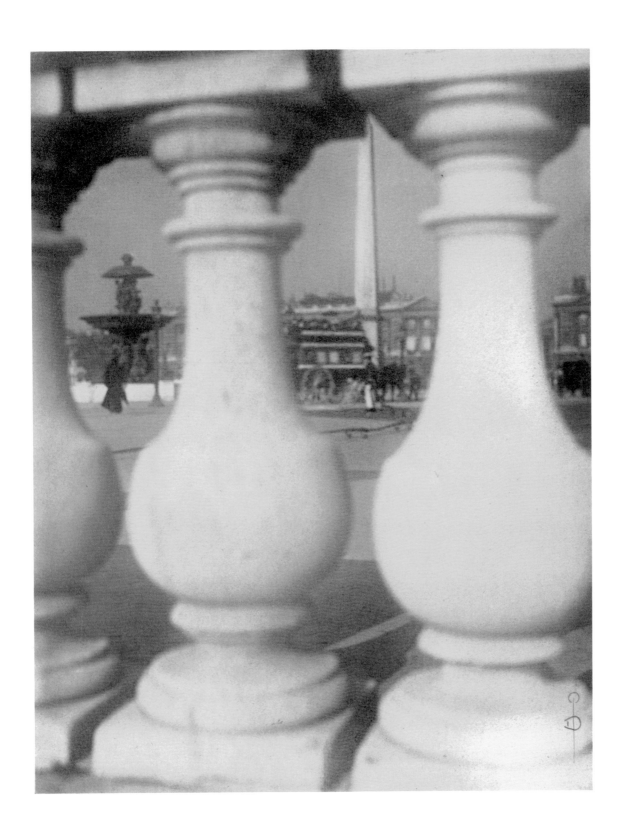

4. Fontaine, Place de la Concorde, 1908

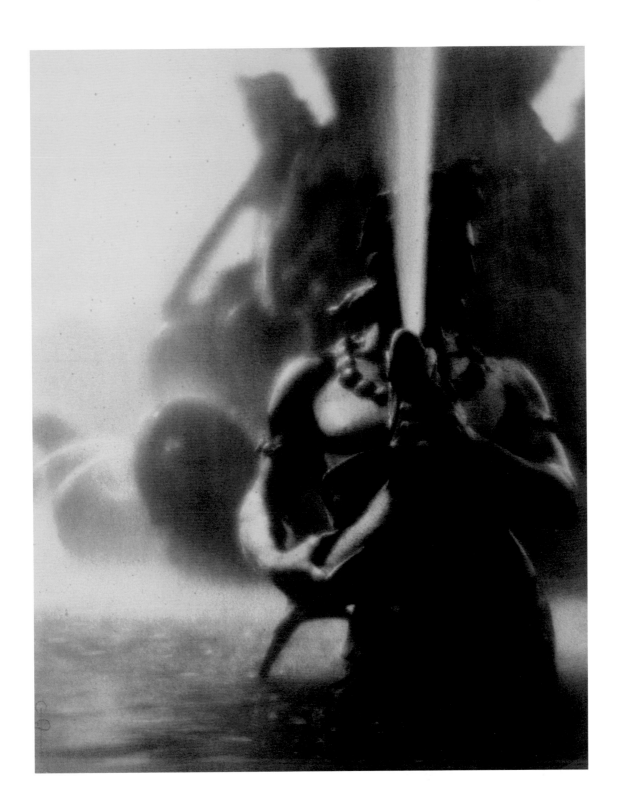

5. *Notre Dame de Paris,* 1908

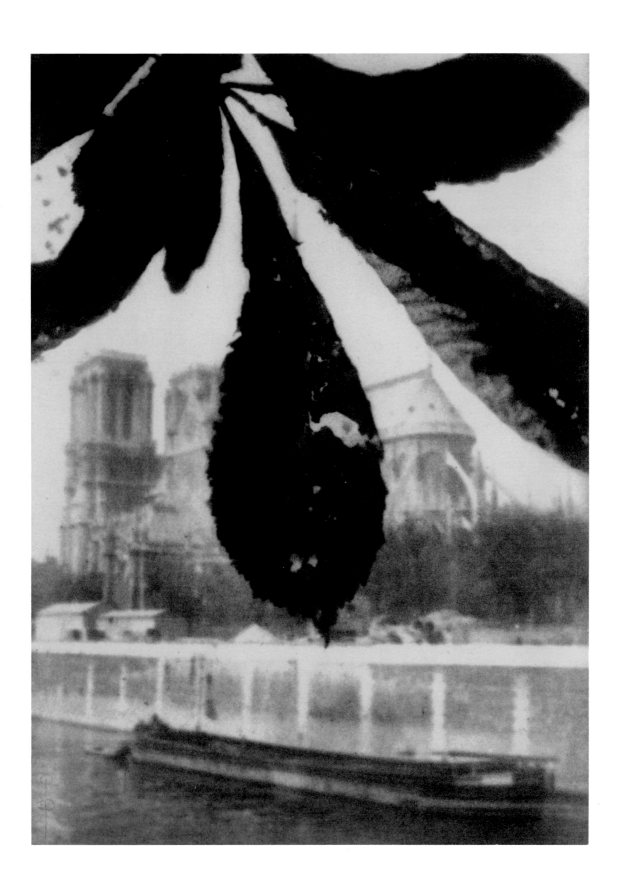

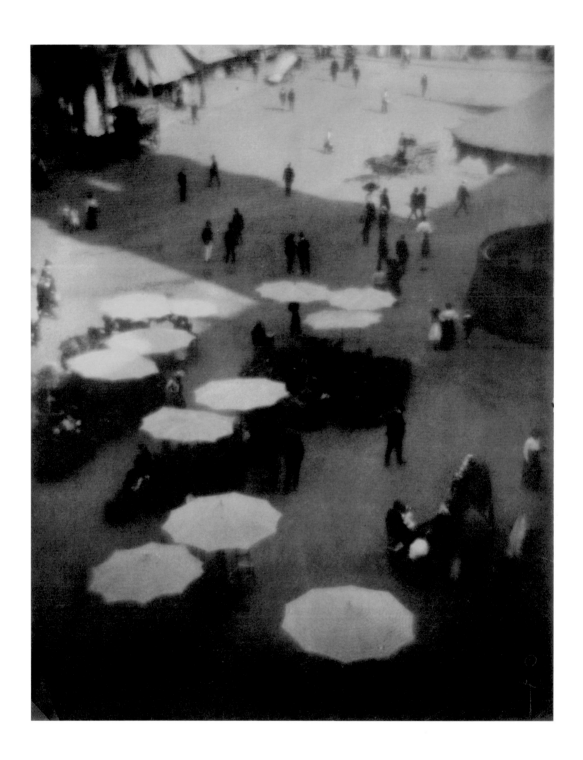

6. *Grand Place, Bruxelles/Grand Place, Brussels,* 1908

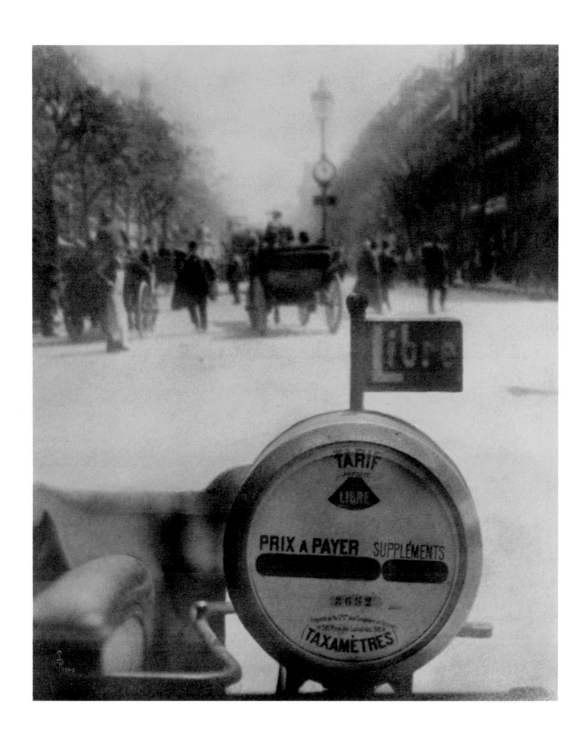

7. *Les Boulevards,* 1909

8. *Petite place de province,* 1908

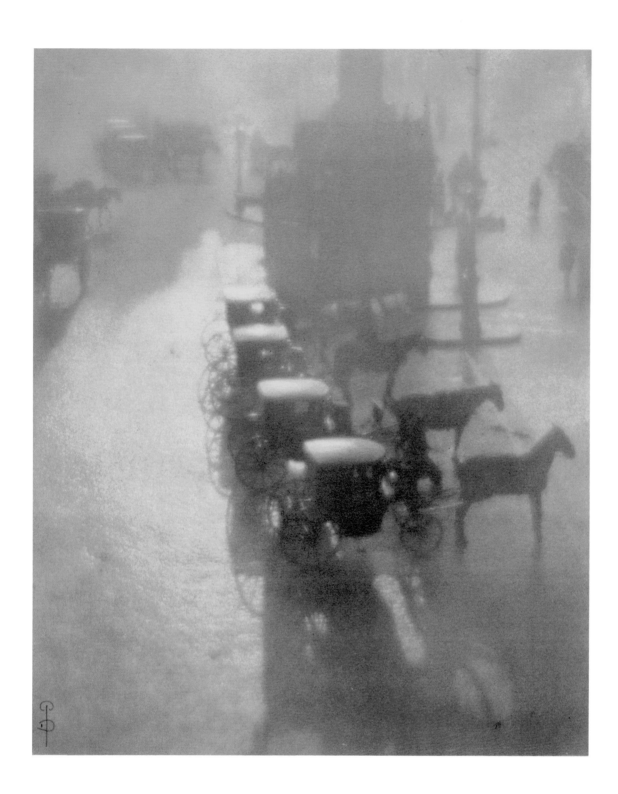

9. Puissance/Mightiness, 1909

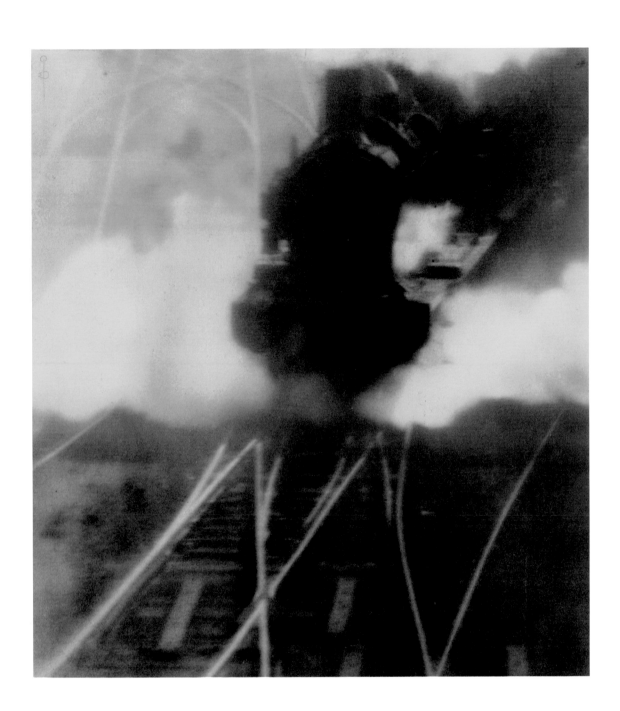

10. *L'Opéra/Jour de Pluie*, 1909

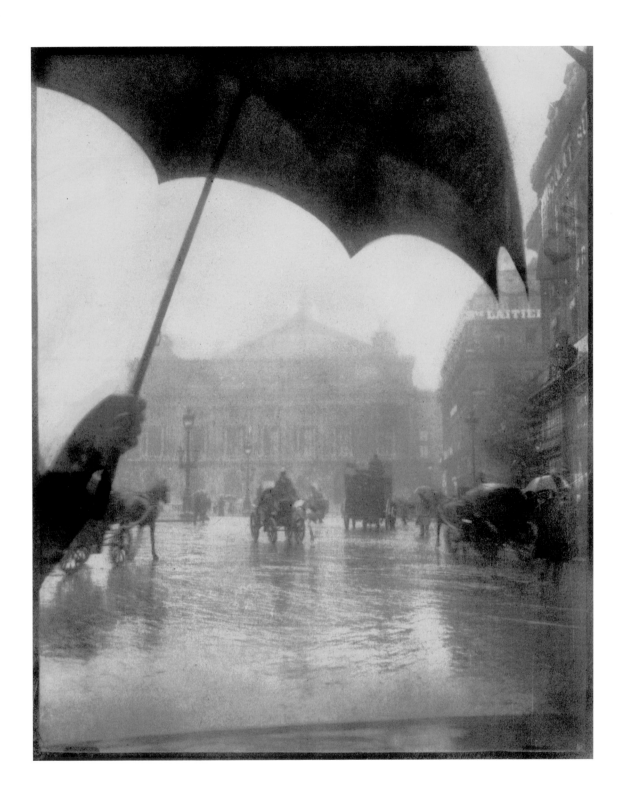

II. *Coin d'Avenue/The Avenue Corner,* 1911

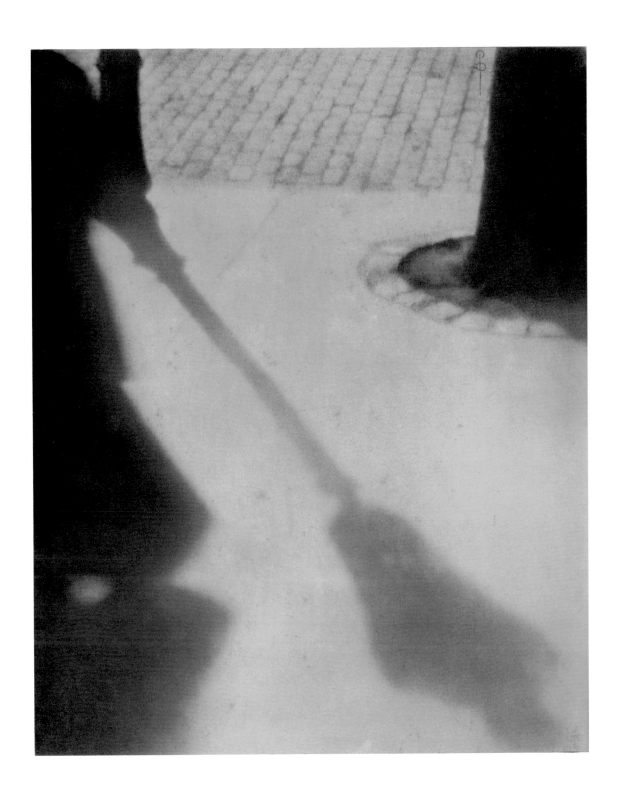

12. *La Fontaine de Carpeaux au Luxembourg,* 1912

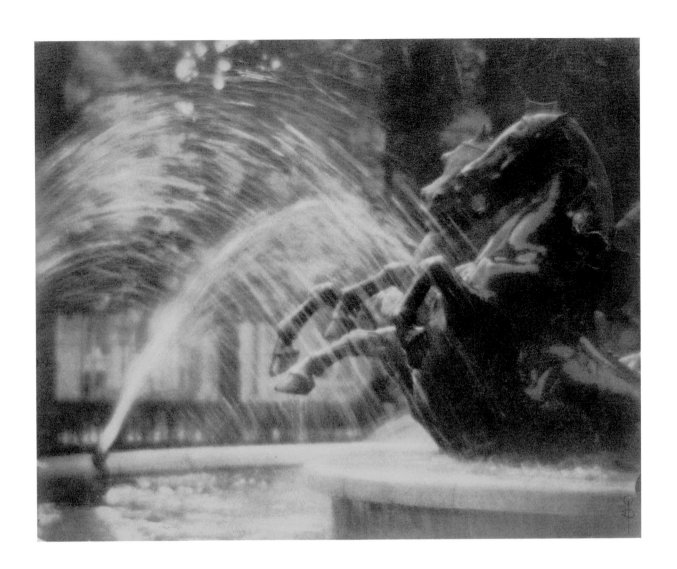

13. *Tempus Fugit/Domain est Mystere,* 1923

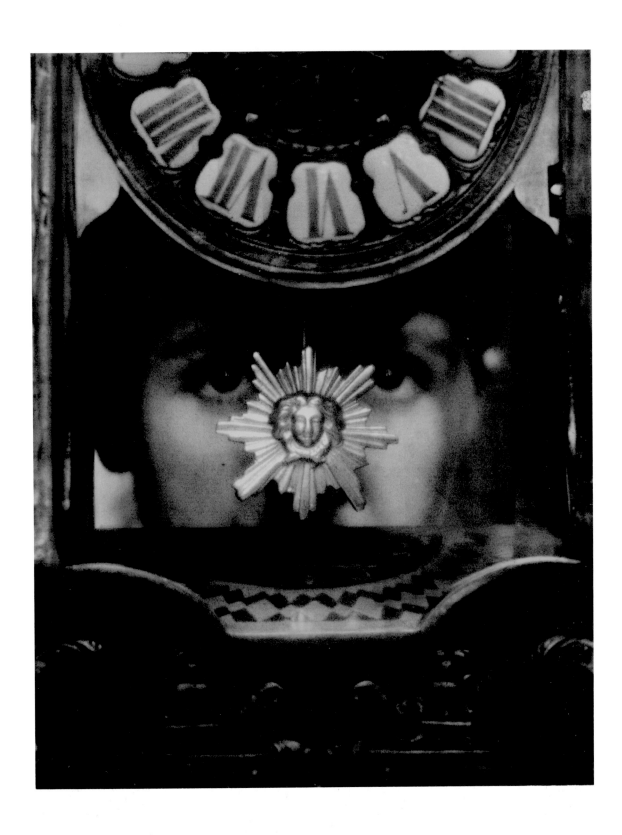

14. *Ardent désir,* 1925

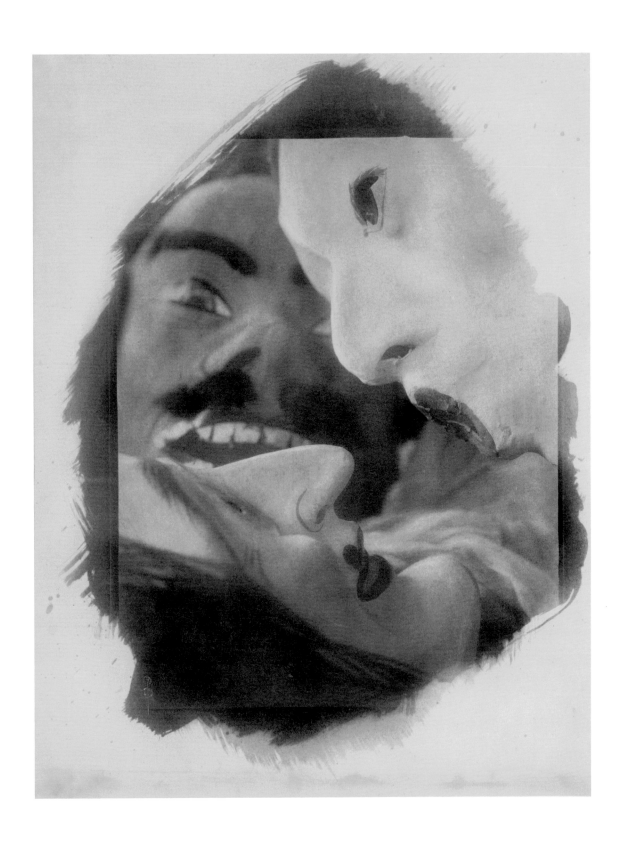

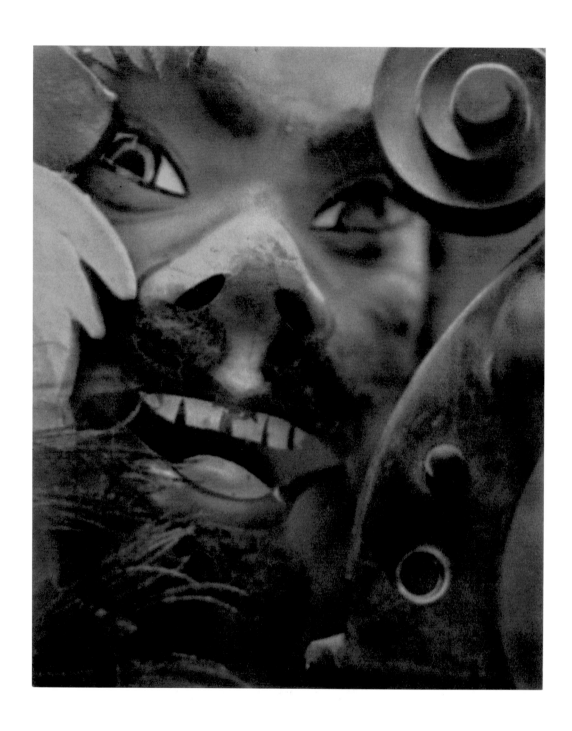

15. *Jazz/Jazz Band,* 1927

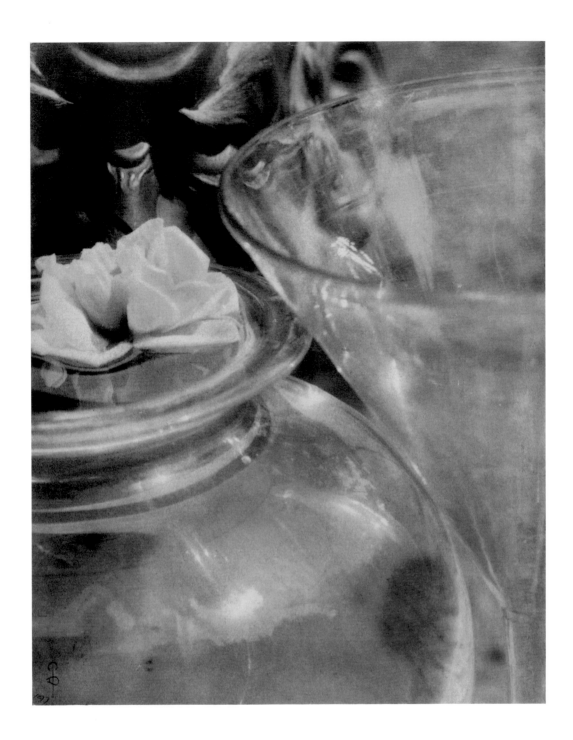

16. *La Rose/The Rose,* 1928

17. *Becs de Cygnes*/*En Souvenir de Denis Papin*, c. 1930

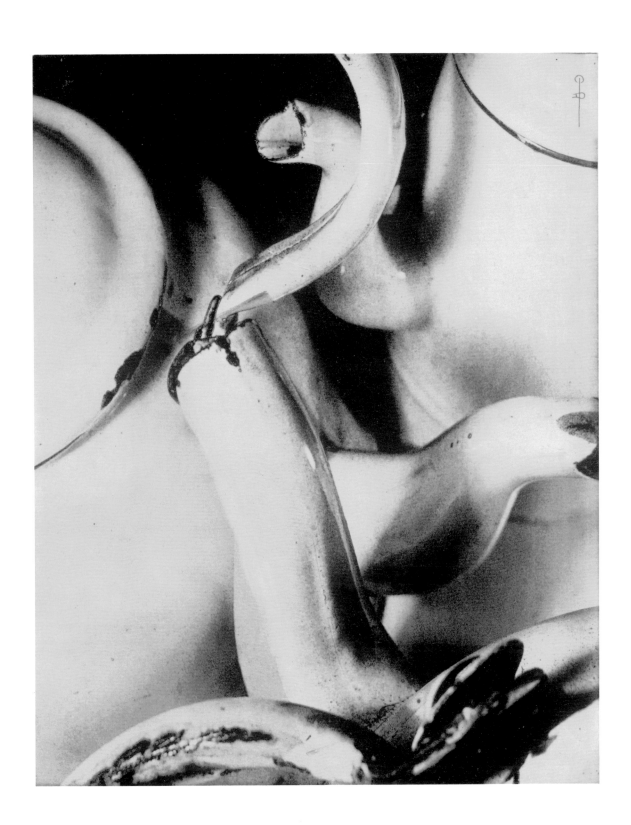

18. *Yo-Yo, c. 1928*

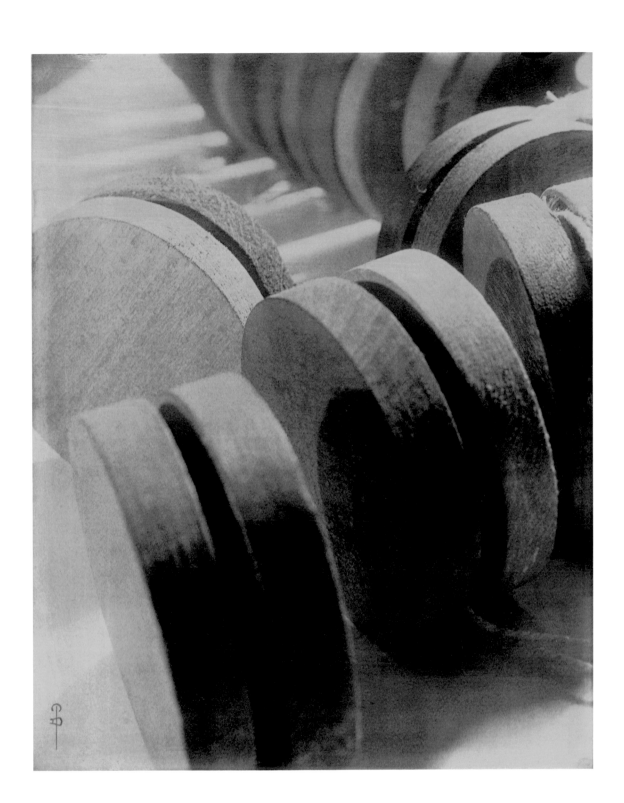

19. *Les Outils*/*The Pressing*, c. 1929

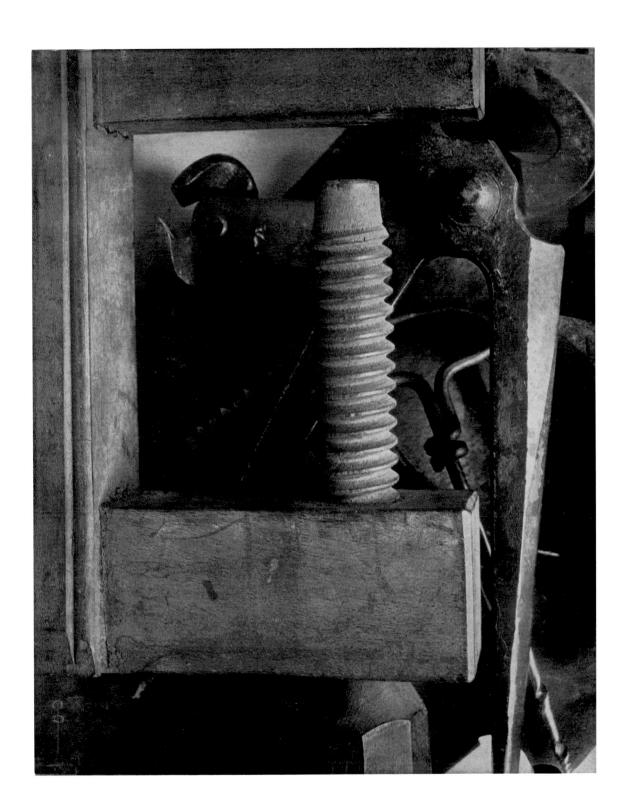

20. *Jour de lavage*/*Washing Day*, c. 1928

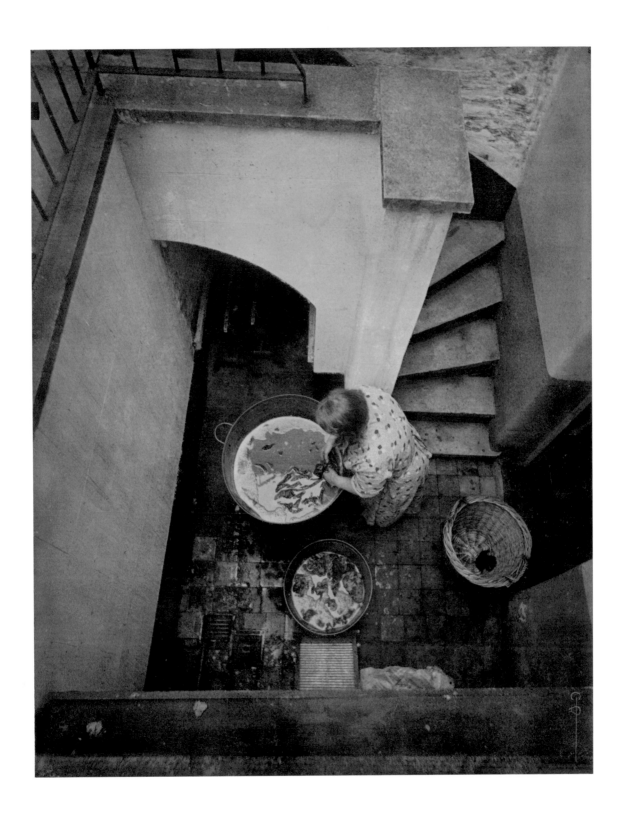

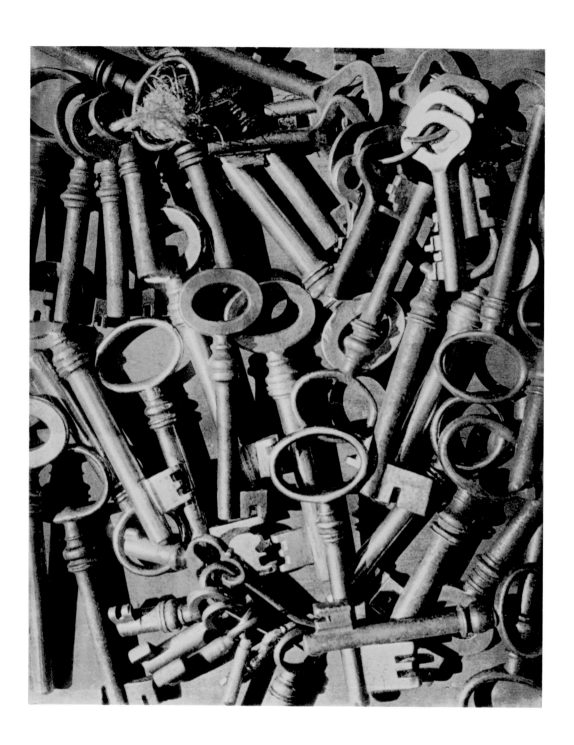

21. *Sésames*, c. 1932

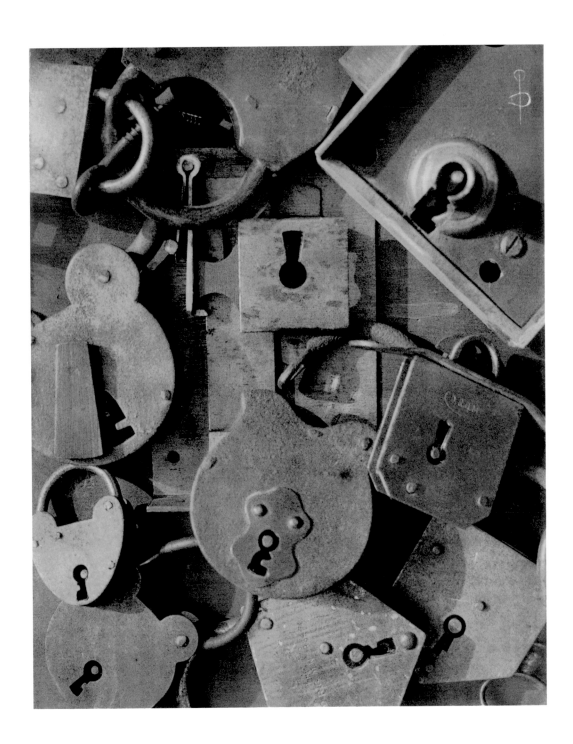

22. *Gardiens fidèles/Padlocks*, c. 1932

23. *Les Quilles/The Skittles,* 1928

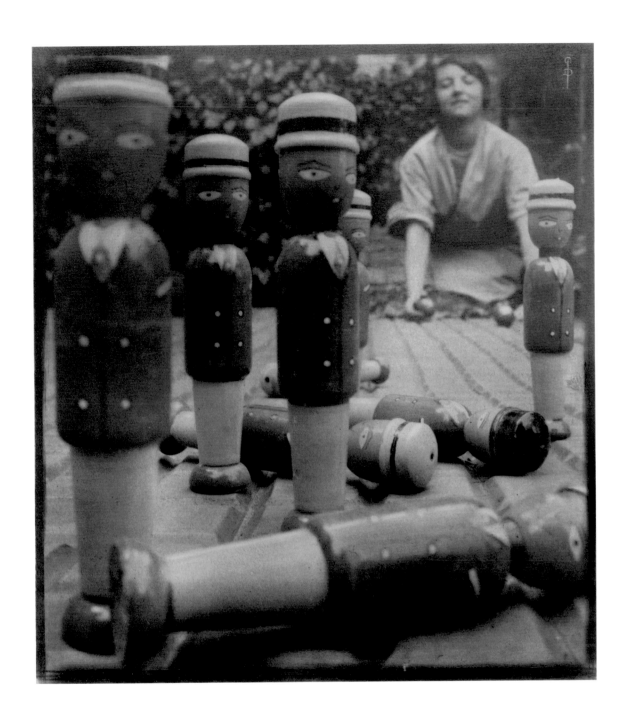

24. *Le Croquet*, c. 1932

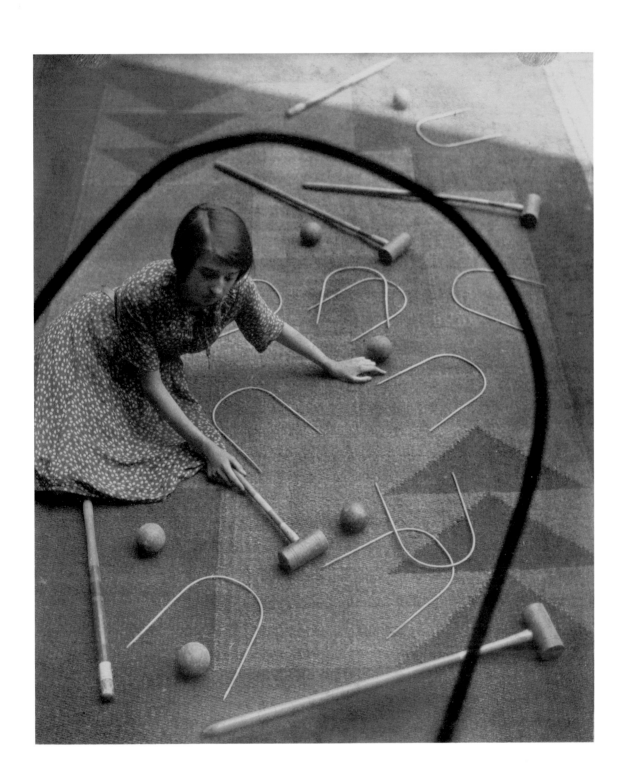

25. *Jeu de Graces/The Ring Toss*, c. 1928

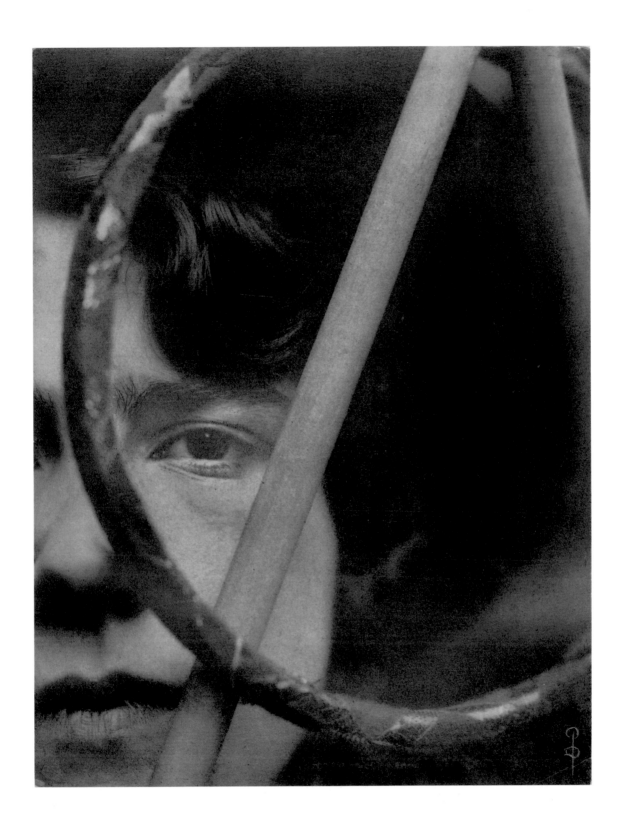

26. *Le premier round/First Round,* c. 1932

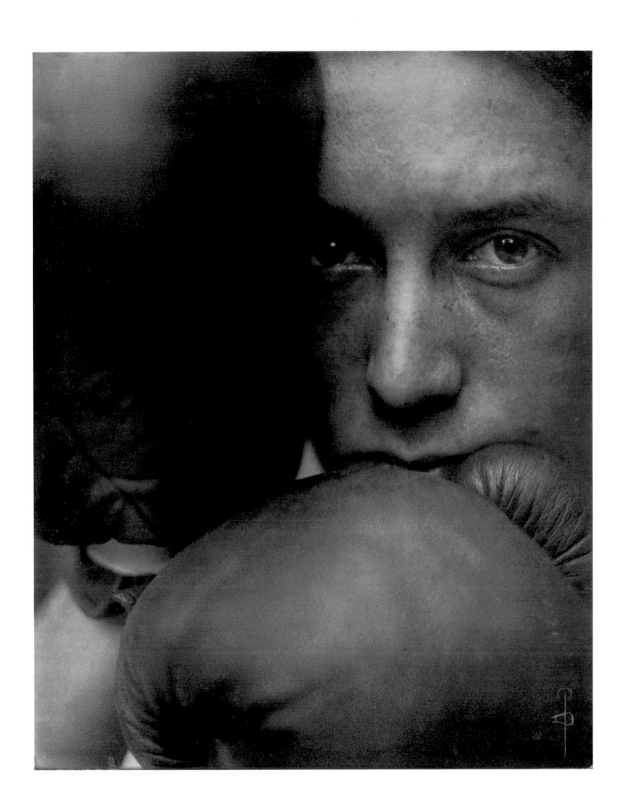

27. *Bobsleigh (Switzerland)*/ [auto portrait, self portrait], c. 1930

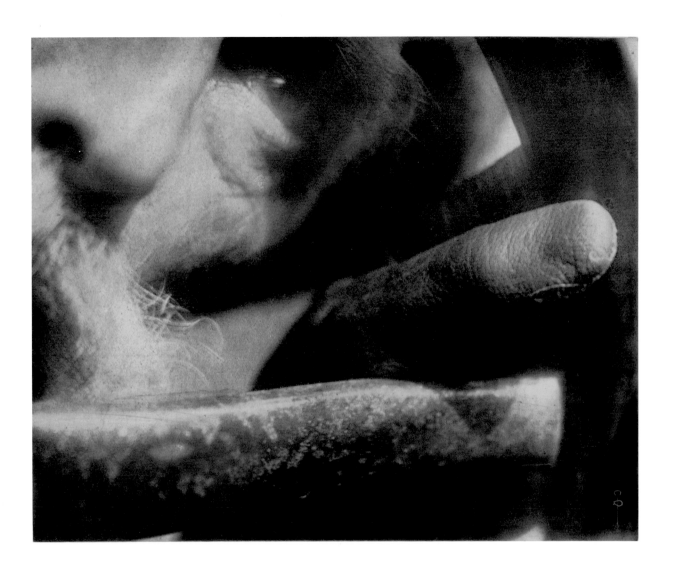

Chronology

1872 Pierre Dubreuil born March 5 in Lille, France.

1888 Begins photography.

1888 Attends Saint-Joseph Jesuit College in Lille. Three years military service: Dragoon
—95 Regiment, Saint Omer.

1896 Five prints shown at the Photo-Club de Paris. Is influenced by H. P. Robinson and Horsley Hinton. Marries Madeleine Marie Verley.

1897 Begins using the Dallmeyer Bergheim soft-focus lens. Daughter Suzanne born.

1898 Renounces use of the hand-held camera and enlargement. Begins using an 8″ by 10″ view camera.

1899 Wins first prize in the Thorton Pickard International Competition with *Cimetière de Campagne.*

1900 Thirty-nine works included in the French photography annual *Annuaire Général et Internationale de la Photographie.* German critic Fritz Loescher hails him as a genius in *Photographische Mitteilungen.* Son George born.

1901 Is greatly influenced by "The New School of American Photography" exhibit in Paris, organized by F. Holland Day.

1903 Elected to The Linked Ring. Builds British cottage-style house, the first in the provinces. Son George dies. Daughter Antoinette born.

1904 Starts printing in the Rawlins oil process.

1907 Separates from his wife.

1908 Makes sojourn to Paris. Produces radical works influenced by the Modernist movements of Cubism and Futurism.

1910 Sends 12 prints to Stieglitz, asking for representation in *Camera Work.* Six prints shown in the Open Section of the Albright Gallery exhibition, Buffalo, New York. Returns to family in Lille.

1912 Presents Stieglitz with five prints for his private collection. Thirty-six page article by Cyrille Ménard on Dubreuil appears in *Photo-Magazine.* First one-man show (64 prints) at the Little Gallery of the *Amateur Photographer Magazine* in London. Coburn produces *The Octopus.*

1914 World War I breaks out. Dubreuil is cut off from his family. German soldiers loot his home, stealing most of his photographic equipment. Ceases photographic activities.

1916 Paul Strand's work appears in *Camera Work.*

1918 Daughter Suzanne dies in the influenza epidemic.

1921 First wife dies.

1923 Resumes photographic activities.

1924 Moves to Belgium. Influenced by Belgian Surrealism, James Ensor and the de Stijl movement in Holland.

1925 Marries Josephine Vanassche. Settles in Brussels.

1928 Sells holdings in Lille. Opens a small tobacco shop in Brussels.

1929 Elected Member of the London Salon. Reaches a new creative peak.

1932 Made President of the Association Belge de Photographie et Cinematographie.

1935 Is given a retrospective exhibition at the Royal Photographic Society. Historian J. Dudley Johnston calls him "…one of the three to whose influence and example the development of the 'New Photography' is to be traced."

1937 Health declines. Produces little new work.

1943 Sells negatives and archives to the Gevaert firm in Mortsel, Belgium. All these materials destroyed when the factory is bombed. Second wife dies.

1944 Pierre Dubreuil dies in obscurity in Grenoble, France, on January 9.

Exhibition Checklist

CENTRE GEORGES POMPIDOU, PARIS
OCTOBER 28, 1987 – JANUARY 5, 1988

NOTE: Works preceded by an asterisk are re-
produced in the catalogue. Dubreuil often
assigned English titles to his works. Where
known, his alternative titles have been listed. In
the measurements, width is preceded by height.

1. [Pietà], 1900.
 Platinum print, 25.8 cm. x 31.5 cm.
 Museum für Kunst und Gewerbe,
 Hamburg.

2. *Fantaisie*, 1900.
 Platinum print, 16.5 cm. x 19.5 cm.
 Private collection.

3. *Bénédicité*, 1901
 Photogravure. 21.2 cm. x 7.4 cm.
 Reproduced in: *Die Kunst in der
 Photographie*, 6st annual, no. 5,
 Berlin, 1902.
 Provinciaal Museum voor Fotographie,
 Anvers.

*4. *Les Volants*, 1901.
 Oil print, 19.7 cm. x 24.5 cm.
 Private collection.

5. *Ballerine*, 1902.
 Platinum print, 23.3 cm. x 13.3 cm.
 The Art Museum, Princeton University.
 Clarence H. White Collection.

*6. *Dans les Coulisses/Behind the Scenes*, 1902.
 Oil print, 24.4 cm. x 19.0 cm.
 Private collection.

7. [Pierrot endormi], 1902.
 Platinum print, 17 cm. x 23.7 cm.
 Provinciaal Museum voor Fotographie,
 Anvers.

8. *Le Croquet*, 1904.
 Platinum print, 18.1 cm. x 22.2 cm.
 The Art Museum, Princeton University.
 Clarence H. White Collection.

9. *Le Croquet*, 1904.
 Silver print, 18.0 cm. x 23.6 cm.
 Provinciaal Museum voor Fotographie,
 Anvers.

10. [Grande roue], circa 1905.
 (Negative, c. 1889)
 Gum-bichromate print, 20.6 cm. x 18.9 cm.
 Musée d'Orsay, Paris.

11. *Versailles*, circa 1905.
 Oil print, 24.8 cm. x 19.7 cm.
 Jonathan Stein Collection, New York.

12. *Départ pour la promenade*, 1907.
 Platinum print, 24.6 cm. x 19.6 cm.
 Provinciaal Museum voor Fotographie,
 Anvers.

*13. *Petite place de province*, 1908.
 Oil print, 24.1 cm. x 19.7 cm.
 Private collection.

14. *Le Grand Manteau Blanc/The Beguinage
 in Winter*, 1908.
 Oil print, 19.7 cm. x 20.7 cm.
 Private collection.

*15. *Fontaine, Place de la Condorde*, 1908.
 Oil print, 24.5 cm. x 19.7 cm.
 Private collection.

*16. *Notre Dame de Paris*, 1908.
 Oil print, 21.4 cm. x 17.5 cm.
 Private collection.

*17. *Eléphantaisie*, 1908.
 Oil print, 24.8 cm. x 19.7 cm.
 Private collection.

*18. *La Place de la Concorde*, 1908.
 Oil print, 23.5 cm. x 19.7 cm.
 Private collection.

*19. *Grand Place, Bruxelles/Grand Place,
Brussels,* 1908.
Oil print, 24.8 cm. x 19.7 cm.
Metropolitan Museum of Art, New York.
Ford Motor Company Collection.
Gift of Ford Motor Company and
John C. Waddell, 1987.

*20. *L'Opéra/Jour de Pluie,* 1909.
Oil print, 25.5 cm. x 20.6 cm.
Private collection.

*21. *Les Boulevards,* 1909.
Oil print, 23.5 cm. x 19.7 cm.
Metropolitan Museum of Art, New York.
Ford Motor Company Collection.
Gift of Ford Motor Company and
John C. Waddell, 1987.

*22. *Puissance/Mightiness,* 1909.
Oil print, 24.1 cm. x 22.2 cm.
Private collection.

23. *Un Geste/Le peintre Jamois,* 1910.
Platinum print, 19.7 cm. x 24.2 cm.
Private collection.

*24. *Interpretation Picasso: The Railway,*
circa 1911.
Oil print, 23.8 cm. x 19.4 cm.
Musée National d'Art Moderne,
Centre Georges Pompidou, Paris.

*25. *Coin d'Avenue/The Avenue Corner,* 1911.
Oil print, 23.5 cm. x 19.4 cm.
Private collection.

26. *La Fontaine de Carpeaux au Luxembourg,*
1912.
Oil print, 19.7 cm. x 24.8 cm.
Private collection.

27. *Emigrants, Naples,* 1912.
Oil print, 24.8 cm. x 20.3 cm.
Private collection.

*28. *Tempus Fugit/Demain est Mystère,* 1923.
Oil print. 24.1 cm. x 19.0 cm.
Private collection.

*29. *Ardent désir,* 1925.
Oil print, 32.1 cm. x 24.8 cm.
Private collection.

30. *Les Deux Masques/Carnaval,* 1925.
Oil print, 24.8 cm. x 20.3 cm.
Private collection.

*31. *Dudule,* circa 1927.
Oil print, 24.1 cm. x 19.0 cm.
Private collection.

*32. *Jazz/Jazz Band,* 1927.
Oil print, 23.3 cm. x 19.4 cm.
Private collection.

33. *Lt. C.A.C. Officier Argentin,* 1928.
Oil print, 24.8 cm. x 19.7 cm.
Private collection.

*34. *Yo-Yo,* circa 1928.
Oil print, 24.4 cm. x 19.7 cm.
Private collection.

*35. *Les Quilles/The Skittles,* 1928.
Oil print, 20 cm. x 18.1 cm.
Private collection.

*36. *Jour de lavage/Washing Day,* circa 1928.
Oil print, 24.8 cm. x 19.7 cm.
Private collection.

37. *Translucidités/Through My Spectacles,* circa
1928.
Oil print, 24.5 cm. by 19.7 cm.
Private collection.

*38. *Jeu de Graces/The Ring Toss,* circa 1928.
Oil print, 24.8 cm. x 19.4 cm.
Private collection.

39. *Mon Pinceau/. . . And my brush,*
circa 1928.
Oil print, 24.8 cm. x 19.7 cm.
Private collection.

*40. *La Rose/The Rose,* 1928.
Oil print, 24.1 cm. x 19.4 cm.
Private collection.

*41. *La Guidatrice/The Woman Driver,* 1928.
Oil print, 24.8 cm. x 20.0 cm.
Private collection.

42. *Lyres modernes*, circa 1929.
Oil print, 20.0 cm. x 24.8 cm.
Metropolitan Museum of Art, New York.
Ford Motor Company Collection.
Gift of Ford Motor Company and
John C. Waddell.

43. *Les trois Masques/The Three Masks/Projet d'Affiche pour "les 3 Masques" (joué au Grand Guignol)*, 1929.
Oil print, 25.1 cm. x 19.7 cm.
Private collection.

44. *Couverture de catalogue de jouets*,
circa 1929.
Oil print, 24.7 cm. x 20.1 cm.
Provinciaal Museum voor Fotographie,
Anvers.

45. *Mon Pékinois/My Pekinese Dog*, 1929.
Oil print, 25.1 cm. x 19.7 cm.
Private collection.

46. *La Cloche á fromage/The Cheese Bowl*,
circa 1929.
Oil print, 24.8 cm. x 20.0 cm.
Private collection.

47. *Douces Amies/Best Friends*, circa 1929.
Oil print, 24.8 cm. x 19.7 cm.
Private collection.

*48. *Les Outils/The Pressing*, circa 1929.
Oil print, 24.6 cm. x 19.7 cm.
Private collection.

*49. *Chantecler*, 1929.
Oil print, 24.8 cm. x 20.0 cm.
Private collection.

*50. *Ombres d'Optique/Spectacles*, circa 1929.
Oil print, 24.5 cm. x 19.7 cm.
Private collection.

*51. *Myself*, 1929.
Oil print, 25.1 cm. x 19.7 cm.
Private collection.

*52. *Au Chat Noir/Projet d'Enseigne pour la Lunetterie "Au Chat Noir,"* 1929.
Oil print, 25.1 cm. x 19.7 cm.
Private collection.

53. *Titan du Ciel/Lieutenant D. . . Aviateur*, 1929.
Oil print, 21.0 cm. x 19.7 cm.
Private collection.

*54. *La comédie humaine/The Puppets*,
circa 1930.
Oil print, 25.4 cm. x 20.6 cm.
Private collection.

*55. *Bobsleigh (Switzerland)/*[a self-portrait],
circa 1930.
Oil print, 19.2 cm. x 24.0 cm.
Private collection.

*56. *Becs de Cygnes/En Souvenir de Denis Papin*,
circa 1930.
Oil print, 24.0 cm. x 19.1 cm.
Private collection.

57. *Antithèse/Antithesis*, circa 1930.
Silver print, 24.8 cm. x 20.0 cm.
Serge Bramly Collection, Paris.

58. *Sourire d'Automne*, circa 1930.
Silver print, 23.8 cm. x 19.5 cm.
Private collection.

59. *Mme. P.D.*, circa 1930.
Oil print, 23.5 cm. x 19.7 cm.
Private collection.

60. *Délice d'Automne/Autumn Smile*, circa 1930.
Oil print, 24.8 cm. x 19.4 cm.
Musée National d' Art Moderne,
Centre Georges Pompidou, Paris

*61. *Concombres*, circa 1930.
Silver print, 39.7 cm. x 29.9 cm.
Private collection.

62. *Des sommets de la Cathédrale d'Anvers*,
circa 1930.
Silver print, 23.4 cm. x 18.2 cm.
Private collection.

63. *Impression de Carême/Eggs*, circa 1931.
Oil print, 24.8 cm. x 19.7 cm.
Private collection.

64. *Cavalerie légère*, circa 1932.
Silver print, 38.7 cm. x 29.9 cm.
Private collection.

*65. *Sesames,* circa 1932.
 Oil print, 24.5 cm. x 19.7 cm.
 Private collection.

*66. *Le premier round/First Round,*
 circa 1932.
 Oil print, 24.5 cm. x 19.7 cm.
 Private collection.

*67. *Mickey/Mickey's Joy,* circa 1932.
 Silver print, 24.0 cm. x 18.0 cm.
 Private collection.

 68. *Through the Lockhole,* circa 1932.
 Oil print, 24.5 cm. x 21.0 cm.
 Private collection.

*69. *Gardiens fidèles/Padlocks,* circa 1932.
 Oil print, 24.8 cm. x 20.0 cm.
 Private collection.

*70. *Le Croquet,* circa 1932.
 Oil print, 23.5 cm. x 19.7 cm.
 Private collection.

 71. *Capriofoliacès,* circa 1932.
 Silver print, 19.7 cm. x 24.1 cm.
 Private collection.

*72. *L'Instrument des Parques,* circa 1932.
 Silver print, 28.1 cm. x 29.2 cm.
 Graham Nash Collection, Los Angeles.

 73. *Mickey,* circa 1932.
 Oil print, 24.8 cm. x 19.8 cm.
 Musée National d'art Moderne,
 Centre Georges Pompidou, Paris.

*74. *Sprint/The Last Effort,* circa 1932.
 Oil print, 19.7 cm. x 21.6 cm.
 Private collection.

 75. *Vieilles Amies/Old Friends,* circa 1933.
 Oil print, 24.8 cm. x 19.7 cm.
 Private collection.

 76. *Sources des Larmes,* circa 1933.
 Oil print, 25.4 cm. x 20.3 cm.
 Private collection.

 77. *Les Gants de Boxe/Boxing Gloves,* circa 1933.
 Oil print, 24.8 cm. x 19.7 cm.
 Private collection.

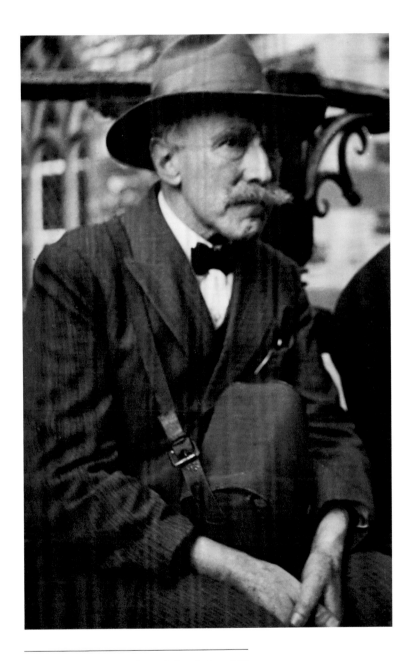

Photographer unknown, *Pierre Dubreuil*, circa. 1932.

Editor: Tom Jacobson

Assistant Editors: Dinah McNichols
Mark-Elliott Lugo

Translators: Marcelle Cooper
Françoise Demerson-Baker
Michel Achard
Michael Hocken

Designed by Patrick Dooley

Tri-tone negatives for the plates
by Richard Benson

1,500 copies printed on Karma natural
by Gardner Lithograph
Buena Park, CA

Binding by Roswell Bookbinding
Phoenix, AZ

Typography set in Perpetua and Gill Sans
by Andresen Tucson Typographic Service, Tucson, AZ